Colin Wiggins with
Philip Conisbee and Juliet Wilson-Bareau

Leon Kossoff *Drawing from Painting*

National Gallery Company, London
Distributed by Yale University Press

This book was published to accompany the exhibition *Leon Kossoff: Drawing from Painting* held at the National Gallery, London, from 14 March to 1 July 2007

© 2007 National Gallery Company Limited

First published in Great Britain in 2007 by
National Gallery Company Limited
St Vincent House · 30 Orange Street
London WC2H 7HH
www.nationalgallery.co.uk

ISBN 13: 978 1 85709 353 7
525500

British Library Cataloguing-in-Publication Data
A catalogue record is available from the British Library
Library of Congress Control Number: 2007921815

Publisher Kate Bell
Project Editor Tom Windross
Picture Researcher Maria Ranauro
Production Jane Hyne and Penny Le Tissier

Designed and typeset in Verdigris by Dalrymple
Printed in Belgium by Die Keure

Front cover: detail from *From Degas: Combing the Hair* (*'La Coiffure'*) [cat. 30]
Opposite title page: Leon Kossoff's studio

Unless otherwise stated, all works are by Leon Kossoff
All measurements give height before width

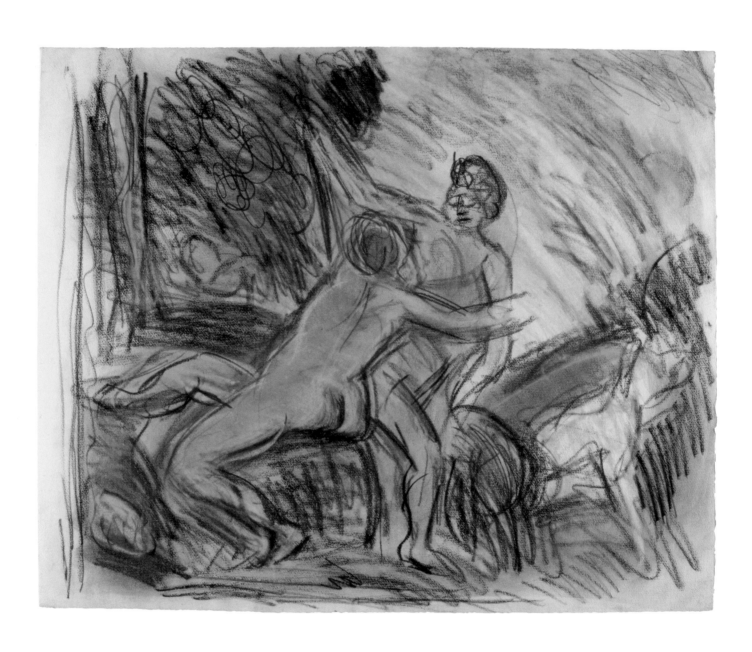

1 | *From Titian: Venus and Adonis*

Black and coloured chalks on paper · 55.2 × 68.5 cm

Director's Foreword

In 1936, when he was just 10 years old, Leon Kossoff first found his way from his childhood home in Hackney to Trafalgar Square. So began his lifelong relationship with the paintings in the National Gallery.

I first visited Leon's studio in north London in 2003. Leon took me into a small, light room at the back of the house and together we looked through many of the hundreds of drawings and prints he has made over the decades, studied and sketched from the Gallery's collection. These works were all bunched together in unkempt heaps, with many sheets battered and creased. It looked like a conservator's nightmare, but the artist has never considered this aspect of his work as something to be particularly treasured, let alone exhibited. He was insistent on pointing out that his work in the National Gallery had always been for him part of his self-education.

In the year 2000, a small selection of his graphic work from Rubens was shown at the National Gallery, as part of the *Encounters* exhibition, held to mark the Millennium. The Gallery had wanted to show Leon's work many years earlier but, up until that time, he had never wanted to show his pictures under the same roof as his artist heroes.

Now, as the artist is 80, we are delighted that he feels at last that the time is right for him to undertake this project. The exhibition's centrepiece is a grand-scale painting of Christchurch Spitalfields, reminding us that Kossoff is a painter of London. His work charts a path across London: Bethnal Green, Spitalfields, St Paul's Cathedral, Dalston, York Way, King's Cross, the Embankment, Kilburn, Willesden Junction, all places he has known for most of his life. It is particularly appropriate to show the painting [cat. 2] here, surrounded by his work from the Old Masters, because it was from beneath its dramatic spire that Kossoff first ventured to the National Gallery to begin his lifelong journey of discovery.

I would like to thank John Lessore and Nicholas Serota for supporting Colin Wiggins's conviction that this exhibition should take place, Juliet Wilson-Bareau and Philip Conisbee for their enlightening essays, Peter Goulds of the L.A. Louver Gallery, David Juda of Annely Juda Fine Art, Ian Barker of the International Museums Agency and Norman Rosenthal. A special note of thanks is due to Ann Dowker, with whom Leon collaborates in the making of his prints and who has provided us with much invaluable help and advice. Most of all, I would like to thank Colin Wiggins, our acting Head of Education, who first wrote about Leon's work as an undergraduate at the University of Manchester and who has nurtured this exhibition into life.

CHARLES SAUMAREZ SMITH
Director, The National Gallery

7

I · PAINTINGS

2 | *Christchurch Spitalfields*, 1999
Oil on board · 213 × 203.5 cm

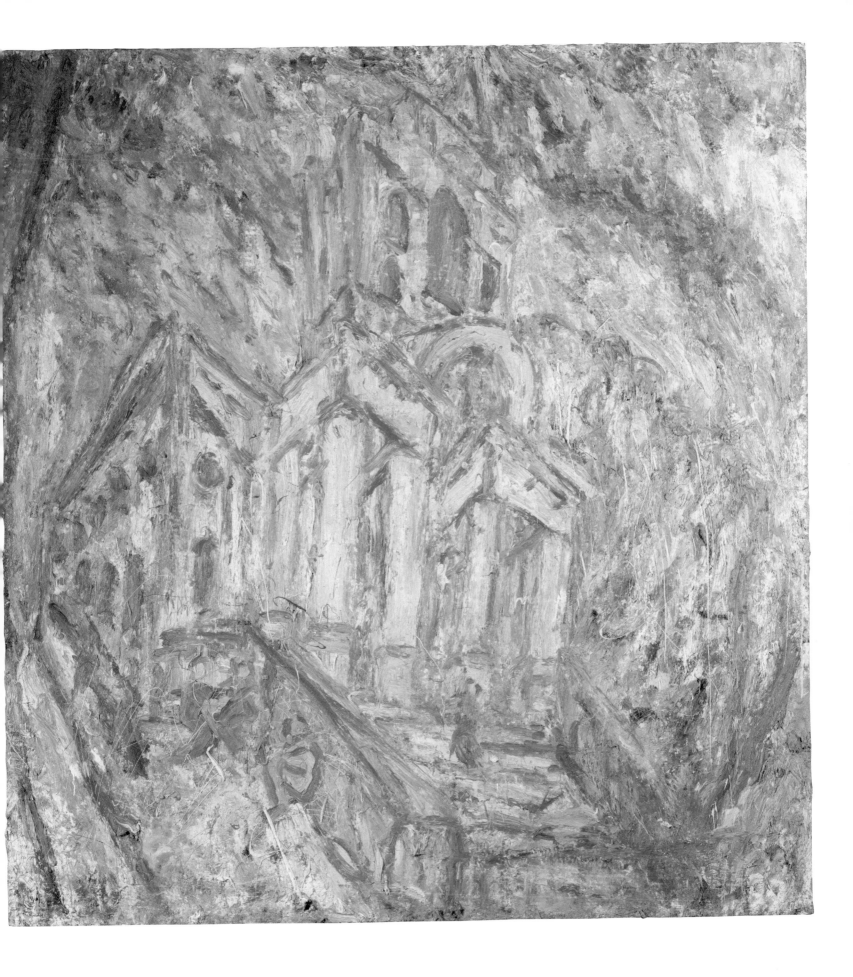

3 | *From Rembrandt: Ecce Homo*, 1999
Oil on board · 142 × 122 cm

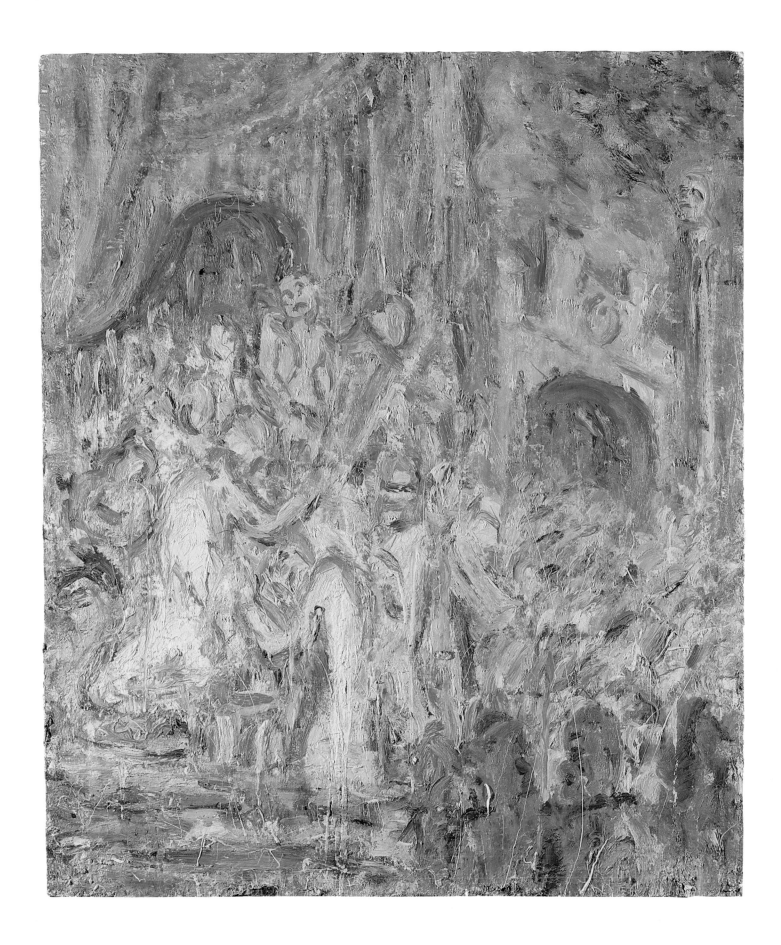

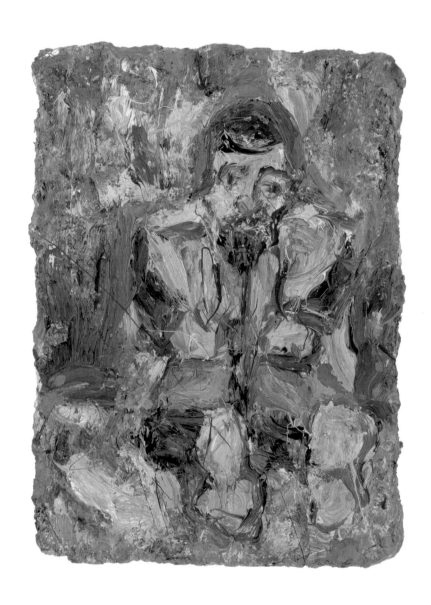

4 | *From Velázquez: Don Sebastián de Morra*, mid 1980s
Oil on board · 42 × 31.7 cm

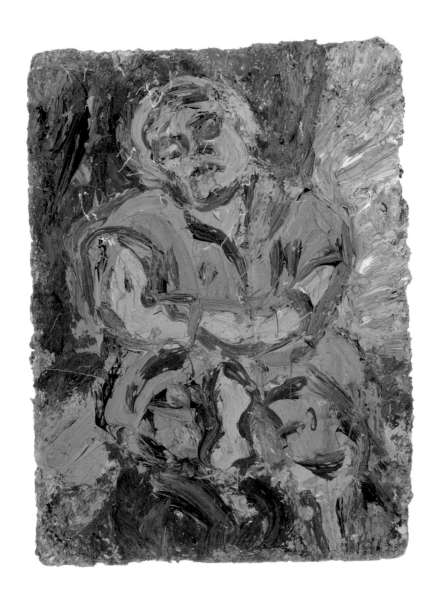

5 | *From Velázquez: Francisco Lezcano*, mid 1980s

Oil on board · 45 × 33 cm

6 | *From Poussin: The Triumph of Pan*, 1998
Oil on board · 135 × 143 cm

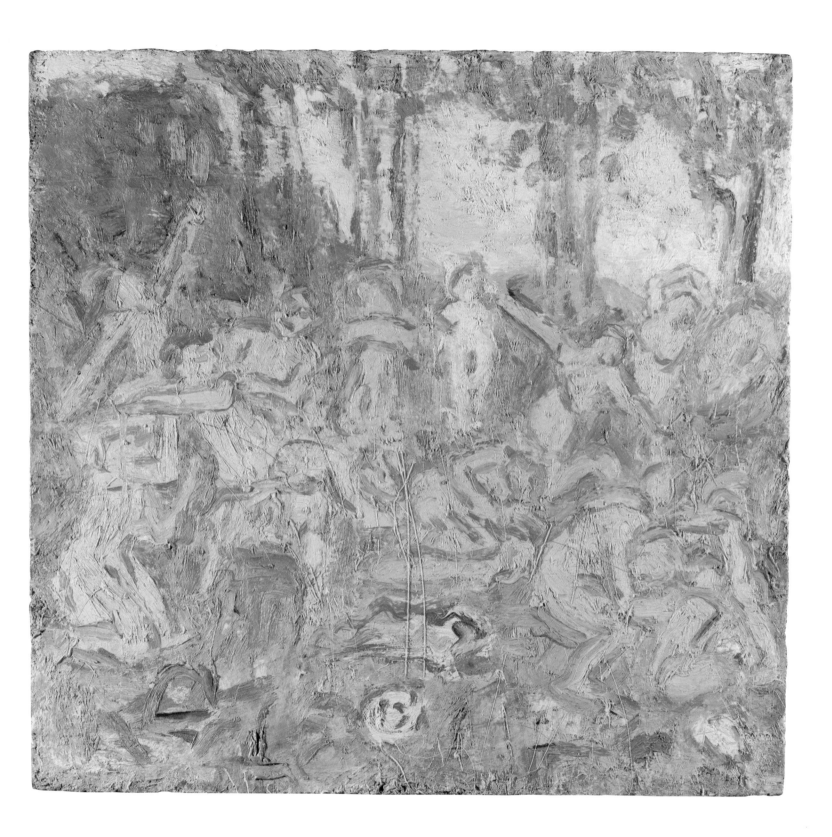

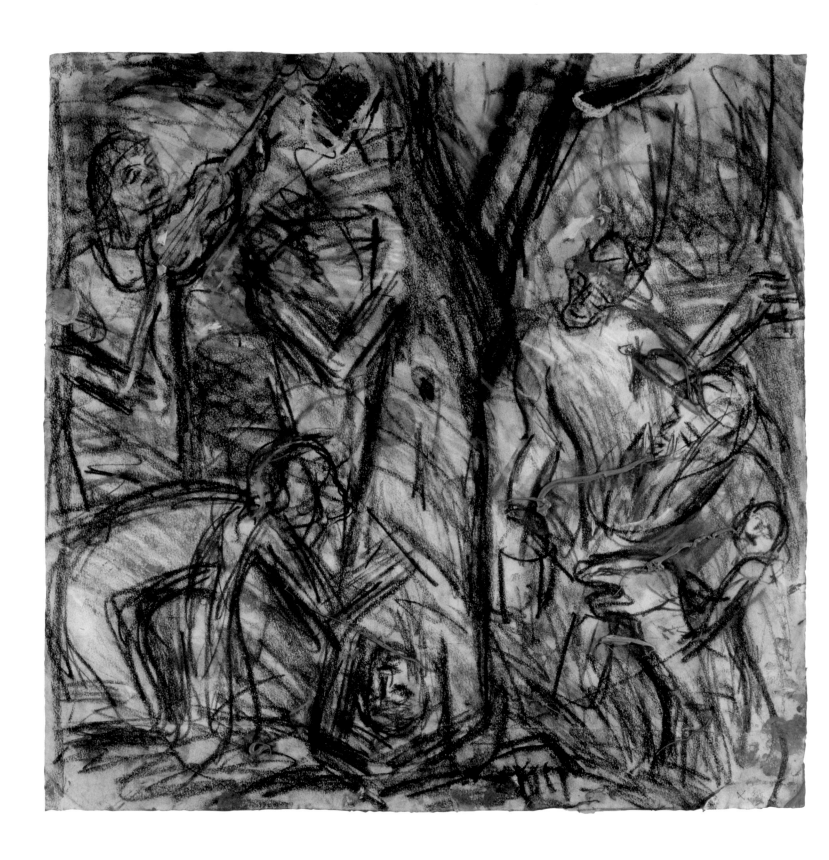

7 | *From Titian: The Flaying of Marsyas*
Charcoal, pastel and oil paint on paper · 57.5 × 59.5 cm

II · DRAWING FROM THE NATIONAL GALLERY & ROYAL ACADEMY

Titian · Veronese · Rubens · Rembrandt
Constable · Degas · Cézanne

8 | *From Veronese: The Consecration of Saint Nicholas (1)*
Black chalk on paper · 76.2 × 56 cm

9 | *From Veronese: The Consecration of Saint Nicholas* (2)

Black chalk on paper · 76.2 × 56 cm

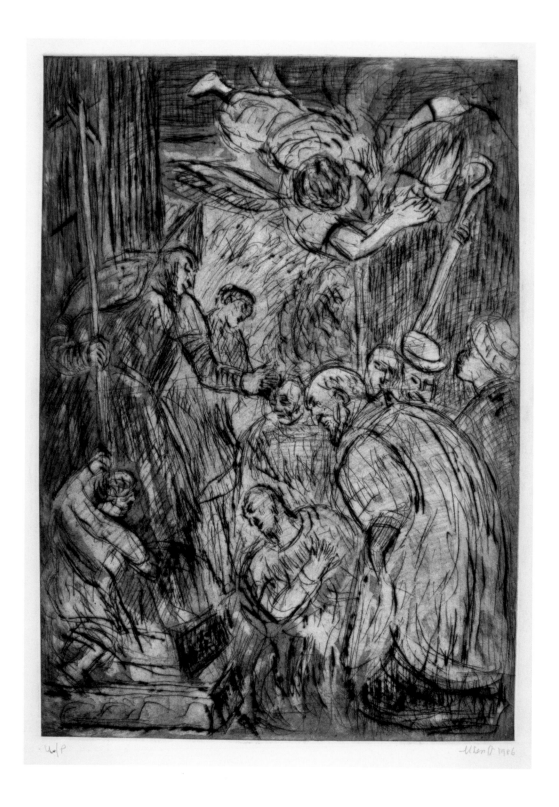

10 | *From Veronese: The Consecration of Saint Nicholas*

Etching, drypoint and aquatint (unique print) · image 56.2 × 40.5 cm

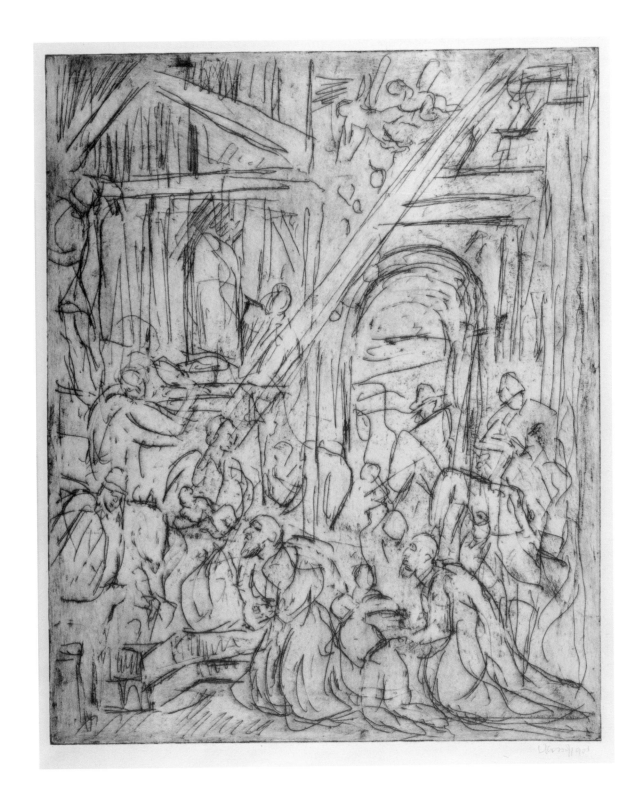

11 | *From Veronese: The Adoration of the Kings*

Etching (unique print) · image 54.8 × 45.3 cm

12 | *From Veronese: The Adoration of the Kings*
Black and coloured chalks on paper · 65.7 × 54.2 cm

13 | *From Veronese: The Adoration of the Kings*
Black chalk on paper · 67 × 58.5 cm

14 | *From Veronese: Allegory of Love, II ('Scorn')*

Mixed media on paper · 56 × 55 cm

15 | *From Veronese: Allegory of Love, IV ('Happy Union')*
Mixed media on paper · 57.2 × 56 cm

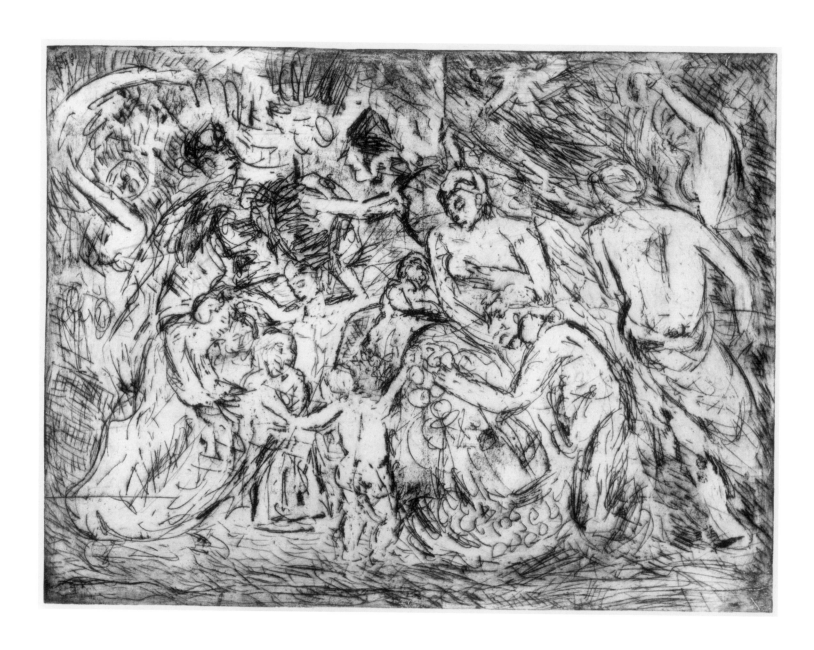

16 | *From Rubens: Minerva protects Pax from Mars* (5)

Etching · image 45 × 60.5 cm

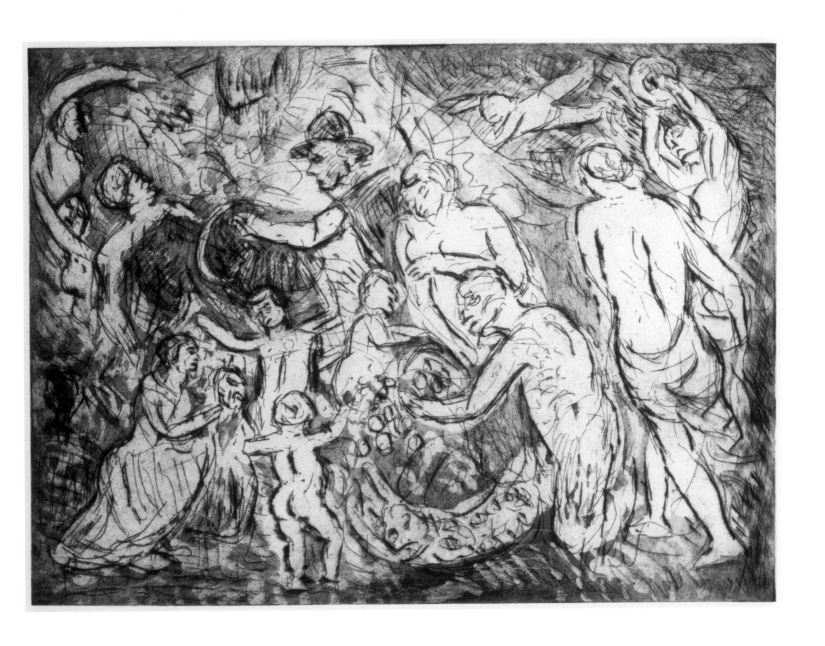

17 | *From Rubens: Minerva protects Pax from Mars* (6)
Etching · image 41 × 57 cm

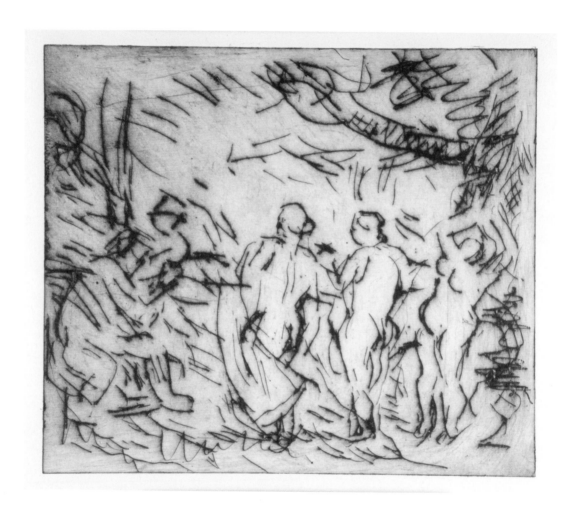

18 | *From Rubens: The Judgement of Paris*

Etching (second state) · image 25.1 × 22.9 cm

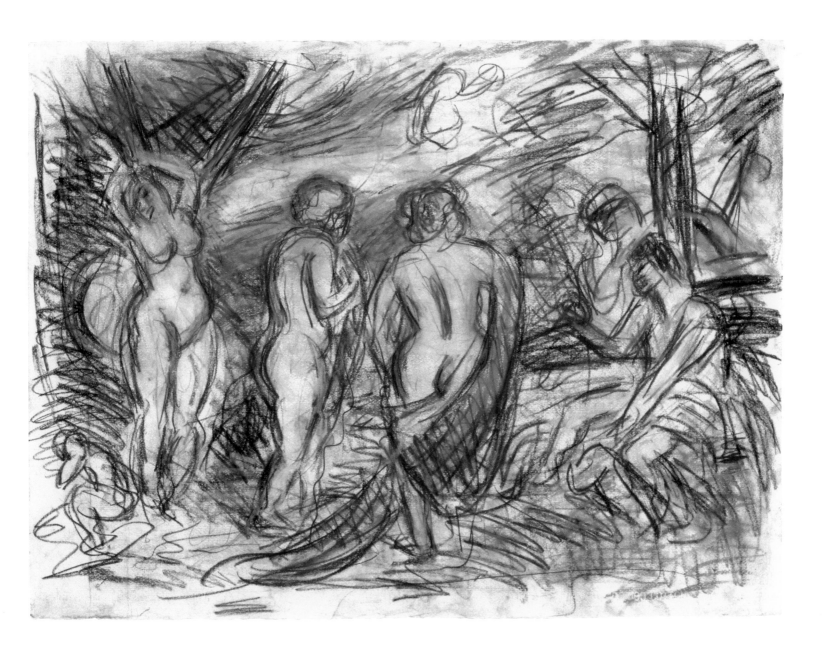

19 | *From Rubens: The Judgement of Paris* (2)
Charcoal and pastel on paper · 56.5 × 76 cm

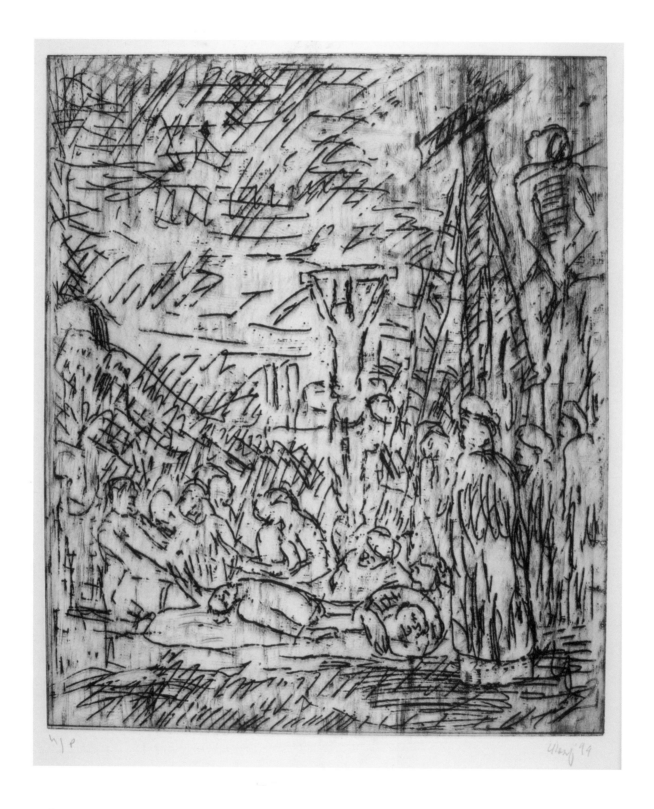

20 | *From Rembrandt: The Lamentation over the Dead Christ*
Etching (unique print) · image 45 × 39.5 cm

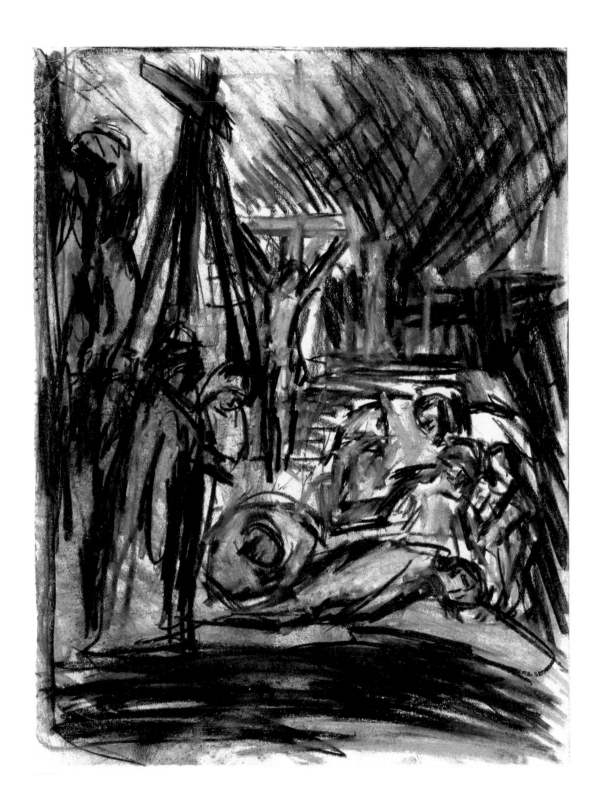

21 | *From Rembrandt: The Lamentation over the Dead Christ*

Black, white and brown chalks · 32 × 24.6 cm · The British Museum, London (1995–5–6–15)

22 | *From Rembrandt: Portrait of Margaretha de Geer*

Black chalk on paper · 38 × 25.5 cm

23 | *From Rembrandt: Portrait of Margaretha de Geer*
Black and coloured chalks on paper · 38 × 28 cm

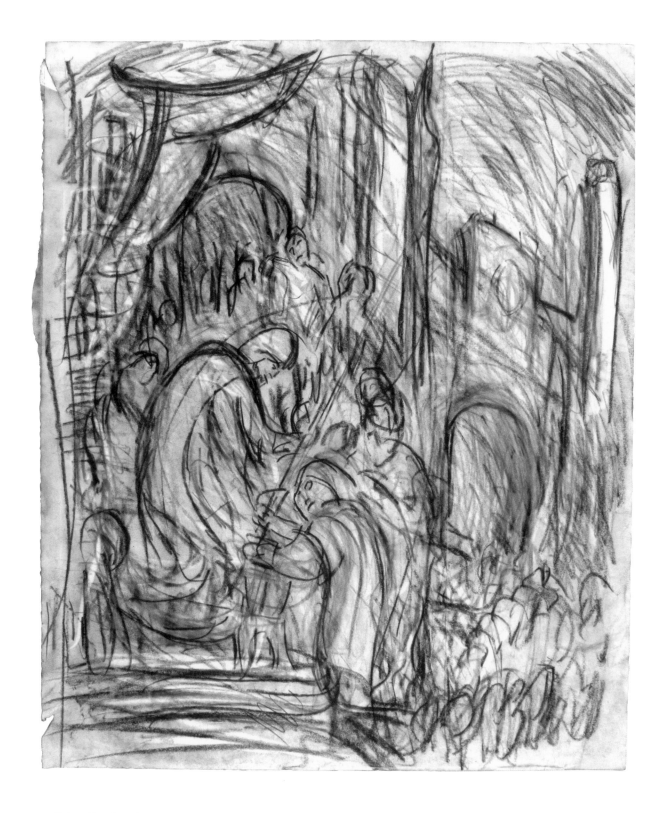

24 | *From Rembrandt: Ecce Homo*

Coloured chalks on paper · 59.3 × 50.8 cm

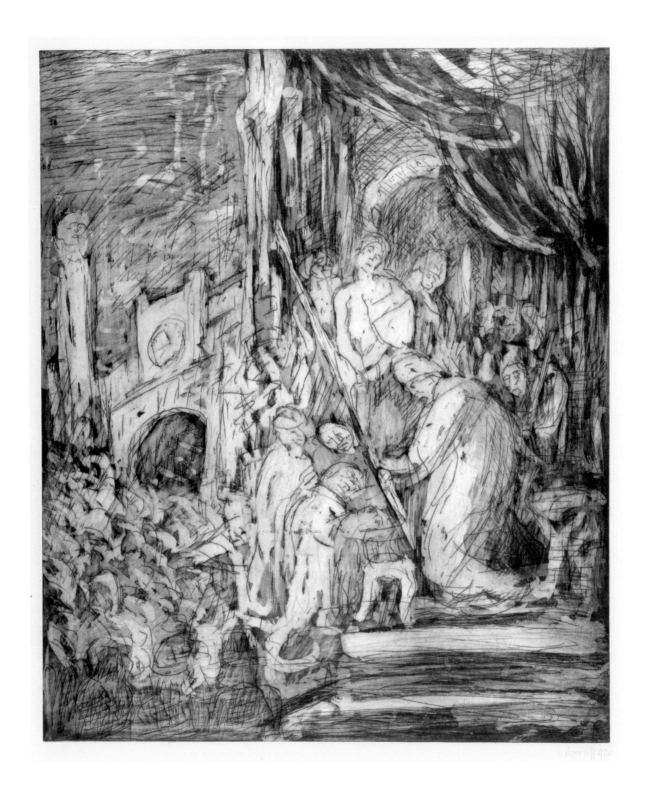

25 | *From Rembrandt: Ecce Homo*
Etching (unique print) · image 55 × 42.6 cm

26 | *From Rembrandt: A Woman bathing in a Stream*

Etching (unique print) · image 19 × 15 cm

U/r Uwe A 90's

27 | *From Constable: Salisbury Cathedral from the Meadows (plate 3)*
Softground etching and aquatint (unique print) · image 43 × 55.5 cm

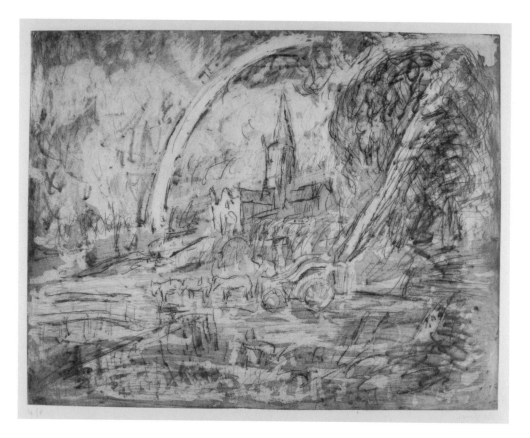

28 | *From Constable: Salisbury Cathedral from the Meadows*
Etching, aquatint and softground etching in red ink (unique print) · image 42.8 × 55.5 cm

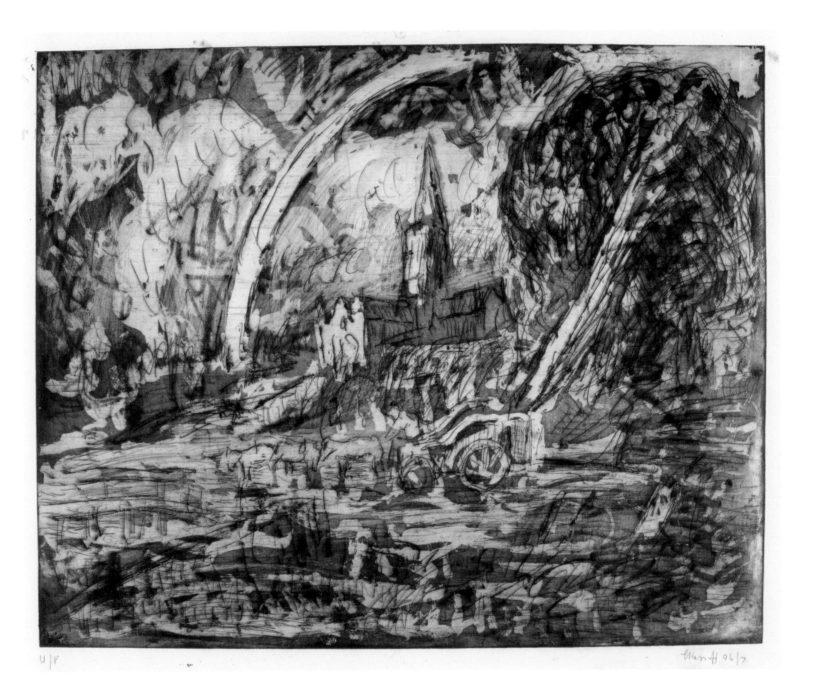

U/P Elen A 96/7

29 | *From Constable: Salisbury Cathedral from the Meadows (plate 3)*
Softground etching and aquatint (unique print) · image 42.7 × 55 cm

30 | *From Degas: Combing the Hair ('La Coiffure')*
Drypoint (unique print) · image 45.5 × 60.2 cm

31 | *From Degas: Hélène Rouart in her Father's Study*
Brown chalk on paper · 50.7 × 38.1 cm

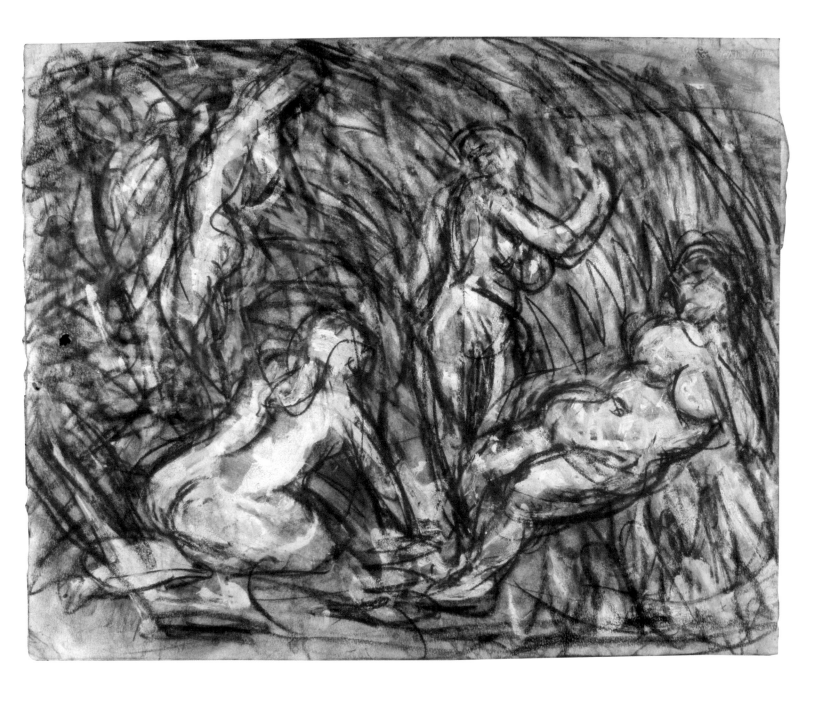

32 | *From Cézanne: The Tempation of Saint Anthony*
Black chalk on paper · 56.8 × 72.8 cm

From the National Gallery *Colin Wiggins*

Leon Kossoff was born in London, in 1926, on City Road in Islington. His early childhood was spent in Shoreditch and Bethnal Green, in the close vicinity of Nicholas Hawksmoor's great masterpiece, Christchurch Spitalfields, a building that was later to become one of his most frequently painted subjects.

Kossoff's relationship with London is multi-faceted. As well as the buildings, streets and people of the city, and his paintings of family and friends in the studio, an equally significant feature of Kossoff's London is the National Gallery. He has made trips there on countless occasions to draw and make prints from works in the collection. Occasionally these visits have inspired the making of paintings back in the studio, from Poussin, Rembrandt or Rubens.

Two of these paintings are included in this exhibition, one from Rembrandt and one from Poussin, together with a large selection of the work on paper. They are joined by two small studies of Velázquez dwarfs, painted in the 1980s and never before exhibited, that were made from reproductions. The exhibition is completed with one of Kossoff's London paintings, *Christchurch Spitalfields* [cat. 2]. The purpose of this exhibition is to investigate the nature of Kossoff's deep relationship with certain artists of the past and more specifically, the paintings of National Gallery.

This is a relationship that has slowly grown deeper over the decades that Kossoff has spent visiting the Gallery. His painted versions of the works by Rembrandt and Poussin, for example, were only made possible by the years that he had spent drawing from the originals. Despite their apparently spontaneous appearance, they were not made in a sudden flurry of activity. The process is one of a slow emergence, which can only happen after a long and deep familiarity has been established.

The Christchurch painting shown here was finished in 1999. Since then, it has been kept in a small back room adjacent to Kossoff's studio, propped up against a wall on a couple of empty paint tins. Already hanging on the same wall was a framed drawing by Kossoff, made in the National Gallery from Poussin's *Cephalus and Aurora* [fig. 21] in 1985. This purely accidental arrangement provided the initial impetus for this exhibition because visitors to Kossoff's studio began to notice, and to comment to the artist, that the large painting and the small drawing seemed to have the same kind of energy, a sense of dynamism that forms a connection between them. Both images shimmer with light, as if they share a common time of day and weather condition. A sharp breeze seems to animate the air. Despite their difference in size, medium and subject, when the two pictures are placed in close proximity they can be read together as representing a continuous world, interrupted only by the short stretch of wall that separates them. Given Kossoff's history as an artist and his continued work from the Old Masters, this connection between the two works should perhaps not be surprising.

Kossoff's art is rooted in the practice of drawing, whether he is outside making preparatory drawings for his London landscapes or working with Poussin and Rembrandt in the National Gallery. His visits to the Gallery began when he was 10 years old although he has no recollection of how he found his way there at such a young age. His first sight of Rembrandt's *A Woman bathing in a Stream* [fig. 25] dates from around that time. Seventy years on, Kossoff remembers that encounter as life-changing and finding himself unexpectedly moved and entranced by the discovery of a whole new world

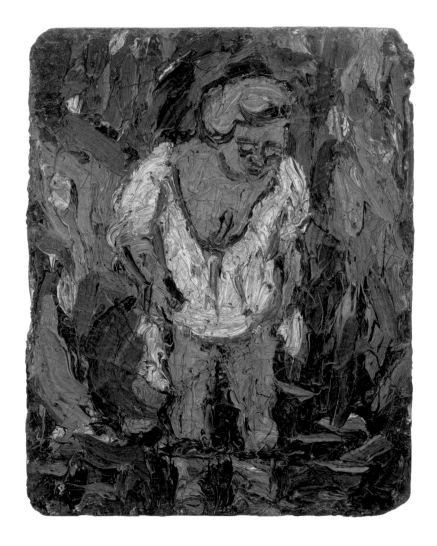

48

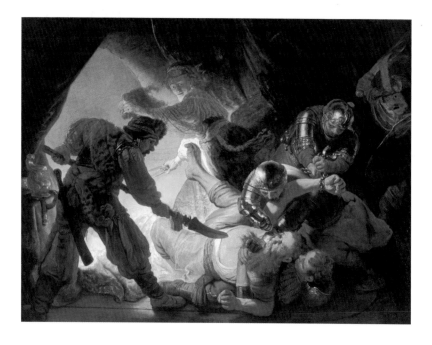

opening up before him. Since then, Rembrandt's little masterpiece has remained a constant favourite and in 1982 prompted Kossoff to produce a small painting in response to it [fig. 1].

Kossoff's trips to draw began when he was a student in the 1950s and he has now produced literally hundreds of drawings from Old Master paintings. In the late 1980s he also began printmaking from works in the Gallery's collection, returning to the same paintings again and again, armed with charcoal and paper or metal plates and an etching needle, as if trying to discover some elusive truth that stubbornly refuses completely to reveal itself. Kossoff's practice of working onto the plate from which the impression will be taken results in a reversed final image, an inevitable by-product of the printing process. This reversal does not concern Kossoff.

Certain loans to the National Gallery of major masterpieces from other collections have also elicited an excited response from Kossoff. For example, he was granted early morning access to the 1992 exhibition, *Rembrandt: the Master and his Workshop*, in order to work from pictures that were only going to be available for a few weeks. The artist was given the same facility when Poussin's *Destruction and Sack of the Temple of Jerusalem* [fig. 23] was hanging in the Gallery, immediately prior to its acquisition by the Israel Museum. He drew [cat. 33] from Rembrandt's *The Blinding of Samson* [fig. 2] under similar circumstances. Kossoff had been fascinated by this painting since his days as a student and yet he had never actually seen it until it was loaned to the Gallery in 1998.

Of necessity, the nature of his relationship with paintings that are visiting London only briefly is different from that with pictures he knows will be there whenever he wants to draw them. Various exhibitions at the Royal Academy have also provoked a strong response and Kossoff has made early morning visits to major shows including the great Venetian exhibition of 1983–4, and exhibitions of Cézanne's early work (1988), Goya (1994) and Poussin (1995).

When he was a student, Kossoff's National Gallery expeditions were made with the purpose of learning

Fig. 1 · *From Rembrandt: A Woman bathing in a Stream*, 1982
Oil on board · 58.4 × 48.3 cm · Private collection

Fig. 2 · Rembrandt (1606–1669) *The Blinding of Samson*, 1636
Oil on canvas · 205 × 272 cm · Städel Museum, Frankfurt am Main (1383)

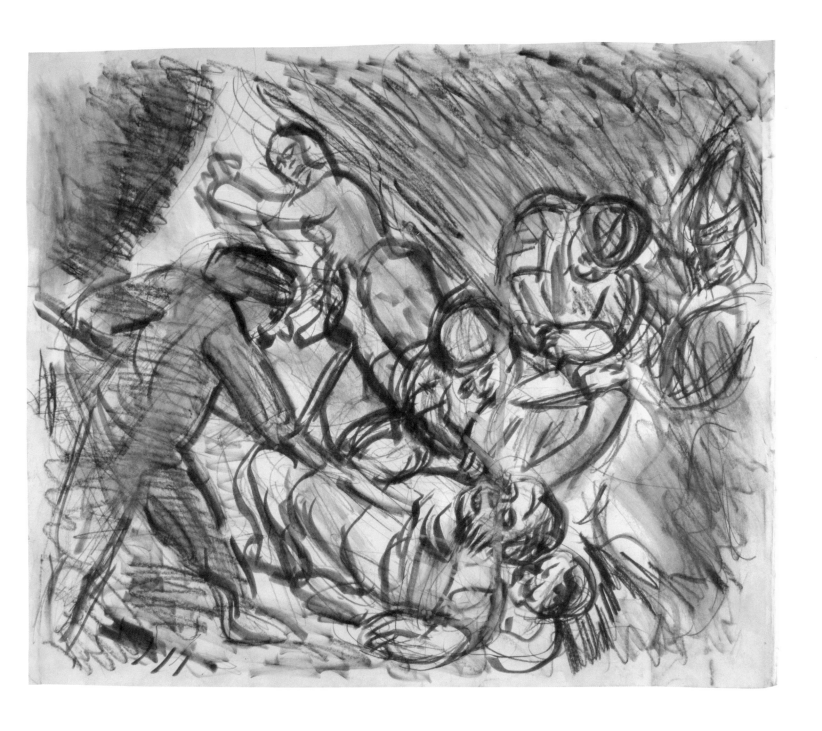

33 | *From Rembrandt: The Blinding of Samson*
Chalk and ink on paper · 55 × 67 cm

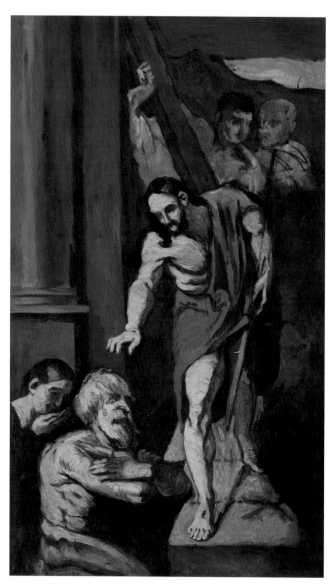

Fig. 3 · Paul Cézanne (1839–1906)
Christ in Limbo, about 1867
Oil on canvas · 170 × 67 cm
Musée d'Orsay, Paris (RF2005–3)

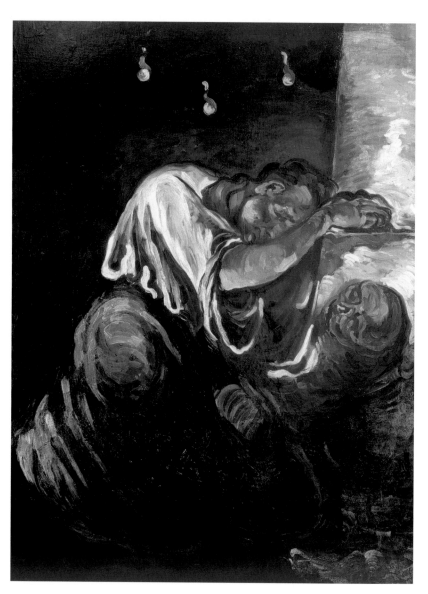

Fig. 4 · Paul Cézanne (1839–1906)
Mary Magdalene, or Sadness, about 1868–9
Oil on canvas · 165 × 125.5 cm
Musée d'Orsay, Paris (RF1952–10)

34 | *From Cézanne: Christ in Limbo*
Black chalk on paper · 72.5 × 56.5 cm

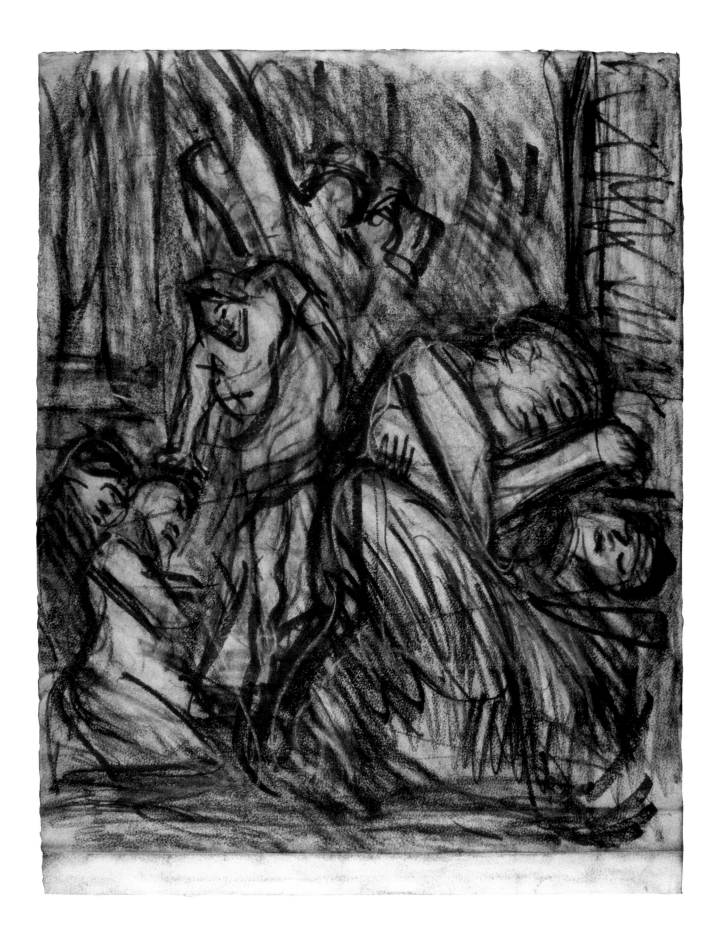

through drawing. This is still true, even though the artist is now 80 years old, and has been working with the collection for more than 50 years. Each time he draws a painting, he is adding to his stock of accumulated memories of it. He remains as awestruck by the qualities he finds in Poussin or Rembrandt as he was when he first discovered them, and has said that the more familiar he becomes with the paintings, the more mysterious they become. The drawings always show signs of a heightened emotional state, as if the artist is working against time. The execution is rapid, the surfaces bear traces of the artist's agitation as he works. The marks, scratches and smudges are like the trowel marks of an archaeologist as he seeks to excavate buried secrets. The drawings were never meant to be mounted and framed and sold. While some have been given away as presents to friends, the vast majority have accrued over the decades in Kossoff's studio, stuffed into drawers or piled up in corners. Consequently it is frequently impossible to provide accurate dates for them, but taken together they become an accumulated record of an artistic career that has been spent pursuing some kind of insight or understanding of great masterpieces.

In a short piece included in the catalogue of his exhibition at the 1995 Venice Biennale, Kossoff wrote, 'Every time the model sits everything has changed. You have changed, she has changed …. The directions you try to remember are no longer there and, whether working from the model or landscape drawings, everything has to be reconstructed daily, many many times.' This statement applies equally to his work from the Old Masters and helps to explain why the artist returns again and again to the same paintings. No single drawing can ever be definitive, each one is a different response to the original.

It is only possible to show a small selection of the work that Kossoff has produced in the National Gallery. The choice was made in close collaboration with the artist, with the aim of demonstrating the range of artists and pictures that he has felt the need to work from. The accident of survival has inevitably played a part in the selection. For example, as a student, Kossoff made many drawings from the early Renaissance collection, but these drawings no longer exist. In contrast, the National Gallery's superb holdings of the paintings of Veronese have prompted a prodigious amount of more recent work that survives in abundance, both drawings and

prints. This work was started in the early 1980s when Kossoff, feeling the need for guidance in the production of his own compositions, found himself drawn to Veronese's grand pictorial constructions.

The seventeenth century has provided Kossoff with enormous stimulus. He has consistently worked from Rembrandt, Hals and Rubens.[1] The earliest of the drawings here is a group made from paintings by Rembrandt and Velázquez [cats 37 and 21–3], tentatively dated to about 1959. They are densely worked in charcoal and brown chalk. In contrast, more recent work from Rembrandt is much lighter in tone. Kossoff's recent etching from *A Woman bathing in a Stream* [cat. 26] is a good example. Rembrandt's painting [fig. 25], has been important to Kossoff since he discovered it in his childhood, and by the time he made the etching, he had worked from the painting hundreds of times. This deep knowledge perhaps explains the lightness and spontaneity of Kossoff's image, where the composition has the freedom of familiarity.

Kossoff's campaign of working from Poussin through the 1980s and 1990s was supplemented by the great 1995 exhibition at the Royal Academy. This work from the French master was itself the subject of two exhibitions held in Los Angeles in 2000, at the Getty and County Museums. At the time Kossoff spoke of the difference between merely looking at a painting and experiencing it.[2] The discipline of repeated drawings made from the same picture enables the artist to familiarise himself with the work to such an extent that he can imaginatively enter into the painting and somehow psychologically inhabit it, rather than just remain on the outside as an observer.

This is beautifully illustrated by a painting made in 1998 from Poussin's *Triumph of Pan* [fig. 17]. It has become conventional for critics and historians to discuss Poussin in terms of his measured draughtsmanship and his rigorously thought-out compositions. He is often cited as the intellectual painter *par excellence*, whose work is seen as the polar opposite of the exuberance and sensuousness of Rubens. Kossoff ignores such an interpretation. For him Poussin is a painter of passion, an artist who communicates as much humanity and warmth as Rembrandt. Kossoff's painted version of *The Triumph of Pan* [cat. 6] was made after the accumulated hours spent drawing from the original had enabled him to

experience the picture on a deeper level than the solely visual. It is through establishing his own private bond with the painting that Kossoff's own painted response emerges. It is as if the artist himself is joining in with the frenzied dance, throwing away his inhibitions and entering into Poussin's pagan world with as much freedom and passion as any of the joyous dancers.

Of later artists, Kossoff's encounter with Goya, prompted by the Royal Academy's 1994 exhibition, has been of seminal importance to him, and Degas and Cézanne are of constant interest. In 1988 Kossoff spent as much time as he could making drawings at the *Early Cézanne* exhibition at the Royal Academy. The drawings from Cézanne are densely worked and dark, perhaps due to the often moving subject matter, although Kossoff consistently denies an interest in any specific narratives in the pictures he draws from. It is always his intention to engage with the structure and the emotion conveyed by the picture itself, and not that simply hinted at by an anecdotal title. One especially notable drawing from Cézanne is a composite work made from two paintings, *Christ in Limbo* and *Mary Magdalene* [cat. 34, with figs 3 and 4] which were originally on one canvas that Cézanne himself cut in two. The two fragments were hung alongside one another at the Royal Academy exhibition and Kossoff's drawing, inspired by that arrangement, is reinstating Cézanne's original composition.

The two works made from Degas shown here are in a higher key. A chalk drawing [cat. 31] made from the portrait of *Hélène Rouart in her Father's Study* [fig. 35] is a skeletal scaffolding of nervous vibration, while a print of deceptively few lines [cat. 30] made from *Combing the Hair ('La Coiffure')* [fig. 36] is one of Kossoff's most immediate images in any medium, with the drypoint lines scratched directly into the zinc plate from which they were later printed. The sparse yet energetic drawing on this plate can only have taken a few moments, its daring economy bringing to mind Whistler's quip that a few moments of work can encapsulate the knowledge of a lifetime.

Of English artists, both Constable and Turner are of great significance to Kossoff. Very little of Kossoff's work from Turner remains, but recent prints from Constable have resulted in dozens of unique proofs. It is apparent that when working in front of a picture by Constable, Kossoff does not see a static composition of paint on canvas but is instead responding to the same ever-changing skies and windswept trees that Constable himself was seeing. Kossoff is especially responsive to the unique quality of the light in Constable's paintings. Each one of the many prints taken from the etched and drypointed plates made in front of *Salisbury Cathedral from the Meadows* [cats 27–9], is packed with a different light and energy, enhancing our understanding of the original [fig. 34]. Although Constable exhibited his painting at the Royal Academy in 1831, he continued to rework it in later years, as if he wanted to keep the picture alive and unfinished forever. Kossoff's repeated reworkings of each plate carry a similar implication: that is, when dealing with a subject in a constant state of flux, Salisbury cathedral in a violent storm, there can never be a moment when the work is definitively finished.

Crucial to the production of these images is Kossoff's relationship with Ann Dowker, who works on Kossoff's plates in collaboration with him. Kossoff has worked with Dowker for over 20 years, and he is keen for her creative contribution to be acknowledged. It is Dowker who bites, inks and prints the plates, in her own studio. Kossoff ascribes the artistic success of their collaboration to the fact that she is herself an artist, not a professional print technician, and that she shares Kossoff's respect for the processes of painting and printmaking.

Kossoff uses printmaking simply as another way of drawing. He works in combinations of etching, drypoint

53

Fig. 5 · John Constable
(1776–1837)
Stoke-by-Nayland, 1836
Oil on canvas · 126 × 169 cm
The Art Institute of Chicago,
Illinois. Mr and Mrs W. W.
Kimball Collection
(1922.4453)

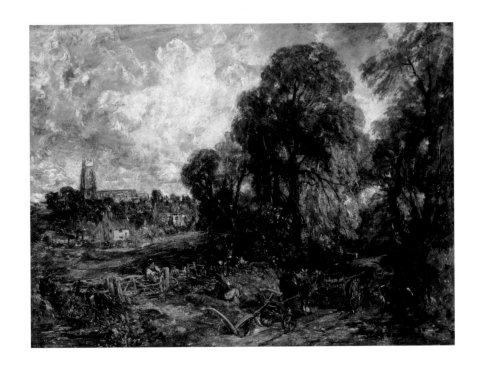

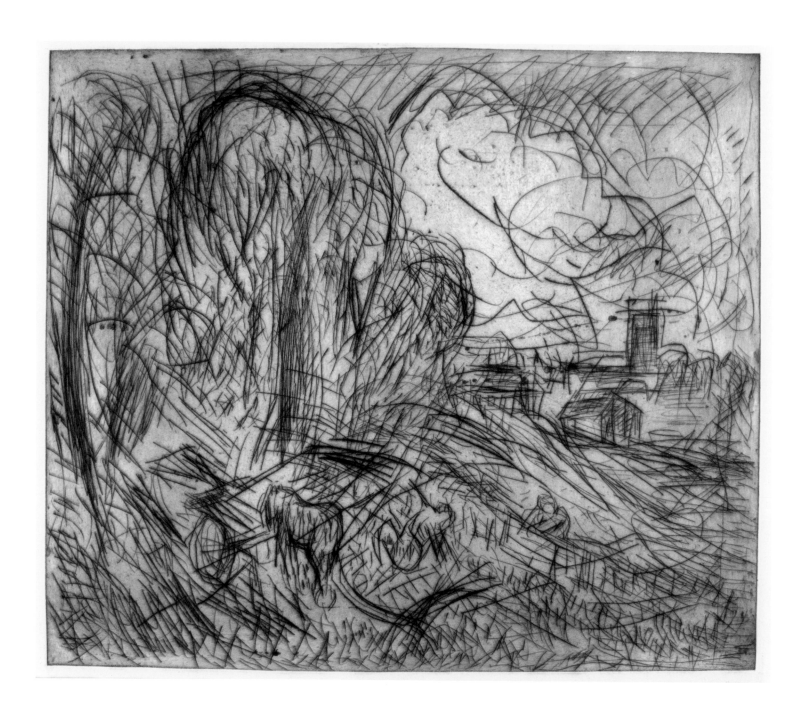

35 | *From Constable: Stoke-by-Nayland (plate 1)*

Drypoint · image 44.5 × 54.7 cm

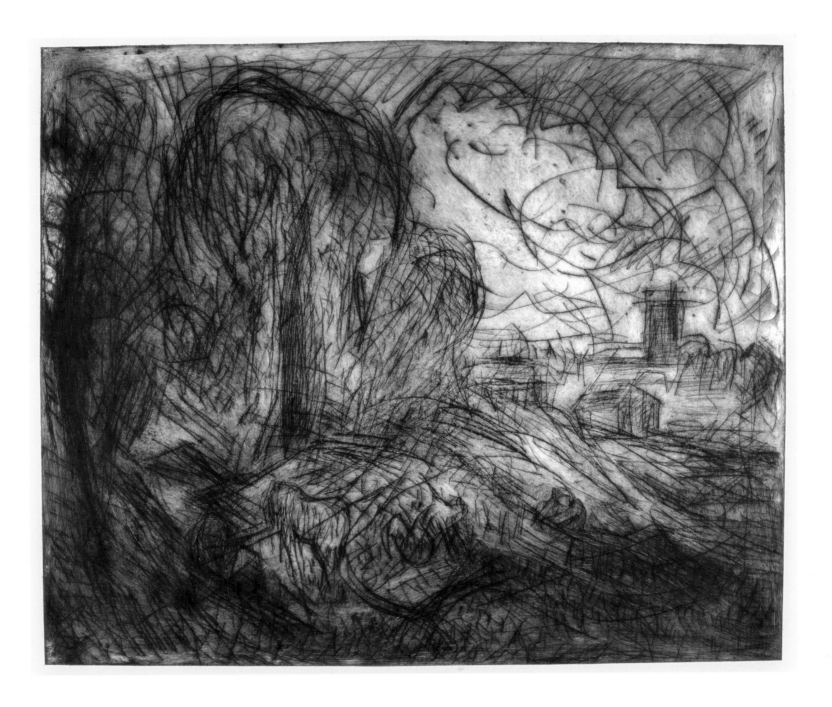

36 | *From Constable: Stoke-by-Nayland*
Drypoint with dark surface tone · 45.2 × 54.7 cm

and aquatint. For Kossoff, the printmaking process is entirely experimental. The plates made after *Salisbury Cathedral from the Meadows* [cats 27–29] were all printed in a variety of different states but there is no definitive or final image. Each pull from the plate functions as an independent expression. The same is true for a series of unique proofs made from Constable's *Stoke-by-Nayland* [fig. 5] which Kossoff worked from when the painting was on loan to Tate Britain in 1991.

This extraordinary variety of images that Kossoff has made from Constable is paralleled by the range and diversity of his pictures of Christchurch Spitalfields [cat. 2]. Kossoff's first painting of the church was made in 1985, when the artist was 59. Since then he has made dozens of drawings, prints and paintings that show the church in different seasons and at different times. A structure familiar from childhood, it is clear that this building has become something of a leitmotif for him. In 1995 he wrote 'The urgency that drives me to work is not only to do with the pressure of the accumulation of memories and with the unique quality of the subject on this particular day but also with the awareness that time is short, that soon the mass of this building will be dwarfed by more looming office blocks and overshad-

owed, the character of the structure will be lost forever, for it is by its monumental flight into unimpeded space that we remember this building.'

A direct impetus for the Christchurch pictures was Kossoff's reading of Peter Ackroyd's haunting novel, *Hawksmoor* (1985), with its powerful sense of time and history. Kossoff's renditions of the church have an organic, quivering quality that implies that the church is not simply an inert construction of bricks and stones but has an urgent life force contained within it. One of the central characteristics of Kossoff's work, whether paintings, drawings or prints, is a sense of enormous visceral energy trapped within the marks made by the artist, which gives his pictures a strong and rhythmic heartbeat that seems to surge through the buildings and streets he represents.

The latest Christchurch painting [cat. 2] was made, as were all of the other paintings that share the subject, in Kossoff's studio. Each session of painting was preceded by a trip to the church to draw it afresh. Each one of these drawings functions as a new discovery, a new encounter with the church, made as if seeing the building for the first time. When back in the studio however, these drawings are not simply used as templates to be copied or

56

Fig. 6 · *From Rembrandt: Ecce Homo* [detail of cat. 24]

Fig. 7 · *King's Cross, Evening II*, 1997
Charcoal and pastel on paper · 59.5 × 84 cm
Private collection

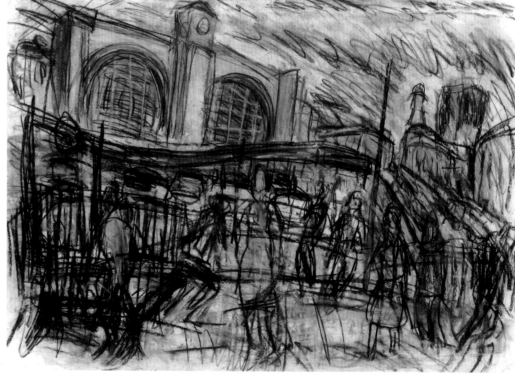

translated into a painting. Kossoff is seeking, when painting, to re-experience the same sensations and responses to the building that he had while working outside and each drawing functions as a fresh impetus. Kossoff's relationship with the building is deepened through his drawings of it, in the same way that his response to Old Master paintings is intensified by making drawings from them. Through his repeated drawings of the church, Kossoff is arriving at a state of not just seeing the building, but experiencing it, in a parallel process to the way he experiences the paintings that he draws from.

Kossoff's painting of *Christchurch Spitalfields* [cat. 2] is packed with light that seems to skid off the densely painted surface. The building soars into the agitated and wind-blown sky as little figures gravitate around it, like tiny moons around a planet. The different figures in the Christchurch paintings are all based upon real individuals, whom either the artist knows personally or has observed while drawing. In this particular painting, they are representations of the groups of homeless people who congregate around the steps of the church. City churches, with their provision of social care, have traditionally become gathering places for London's homeless and during Kossoff's many expeditions to draw the church he became familiar with certain characters who would often show an interest in his work. London's indigent population of wanderers, who seek comfort in the shadow of the church, are represented by an artist whose family were once themselves wanderers, finding refuge in this part of London.

Kossoff's painting after Rembrandt's *Ecce Homo* [cat. 3] provides a great example of the inevitable cross-over between the artist's practice of working from Old Master paintings [fig. 27] and his London landscapes. The painting was finished in 1999, and was made concurrently with a campaign of painting and drawing from the landscape around King's Cross. Figures scurry across the front of these pictures [fig. 7] while behind them the familiar arches and clock-tower identify the location. Kossoff made regular visits to King's Cross to draw and, in his usual way, would bring the drawings home to his studio as part of the preparation for the paintings.

The painting from Rembrandt [cat. 3] was made according to the same principles. Before each session of work Kossoff would travel to the National Gallery and make new drawings from Rembrandt's little painting and, just as with the King's Cross drawings, they would be brought back to the studio to work from. His finished painting is considerably larger than Rembrandt's original and, like the Rembrandt, it is painted entirely in earth colours. Seen behind the crowd of onlookers is an architectural construction with an arch and a clock, strikingly similar to the arches and clock of the King's Cross pictures. The similarity is such that it is tempting to over-interpret and see Kossoff's rendition of Rembrandt's Biblical scene as having been relocated to modern day London. Indeed, a Christian theologian may well be delighted with such an idea but Kossoff swiftly rejects it and attributes the similarity to no more than coincidence.

Kossoff first worked from Rembrandt's *Ecce Homo* in his student days. He has gone back to it regularly ever since until finally, in 1999, this painting emerged. Even this may not be his last word. This is a beautiful instance of how his relationship with certain paintings develops and grows, with memories of past encounters contributing, perhaps unconsciously, to the final painting.

It is conventional to use the word 'after' when talking of an artist's variations on the work of his predecessors. Kossoff however, is adamant that his preferred preposition is 'from', as in 'drawn from'.[3] It is worth reflecting upon the nature of this expression. Drawing, in an artistic context, is taken to mean the making of marks on paper with implements such as pens, pencils or brushes. These marks can be made to represent something that the artist is looking at, while attempting to transcribe visual reality onto a two-dimensional surface. But the word 'draw' can also apply to a different kind of action entirely: a soldier can draw a sword from its scabbard, or an executioner can draw the bowels from a condemned prisoner. More abstractly, one can draw a conclusion. In this context the word means 'to extract' or 'to take out', an understanding that is very relevant to Kossoff's procedure. He responds to a particular painting from the past with his own method of mark making. The result is work that is drawn in a practical sense, with charcoal or printing ink. Yet it is also drawn in a metaphysical sense, drawn 'from' the painting in a way that brings out his understanding of the work into realisation and allows the viewer to share in the discoveries that he has made through 50 years of dedicated application.

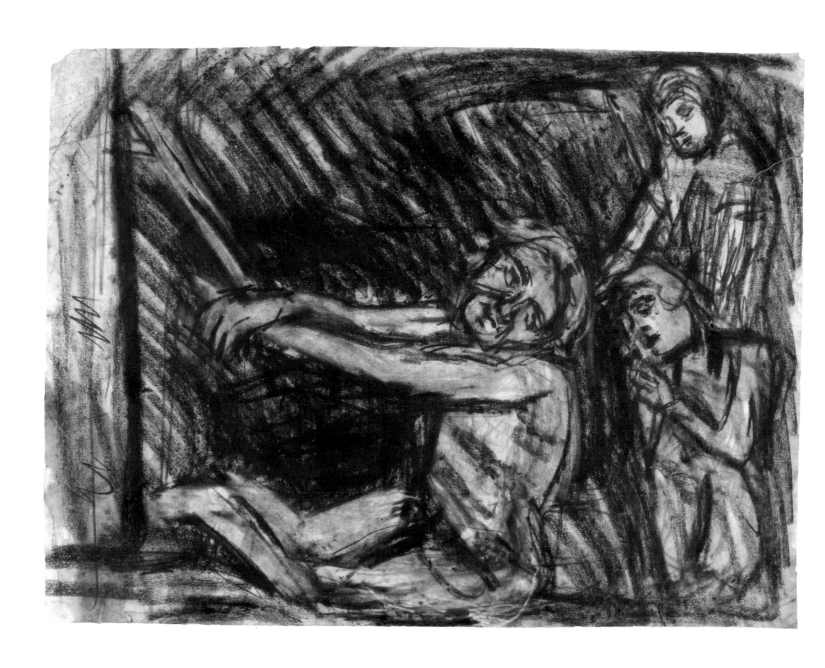

37 | *From Velázquez: Christ after the Flagellation, contemplated by the Christian Soul*
Black chalk on paper · 42 × 59.2 cm

III · DRAWING FROM SPAIN

Velázquez · Goya

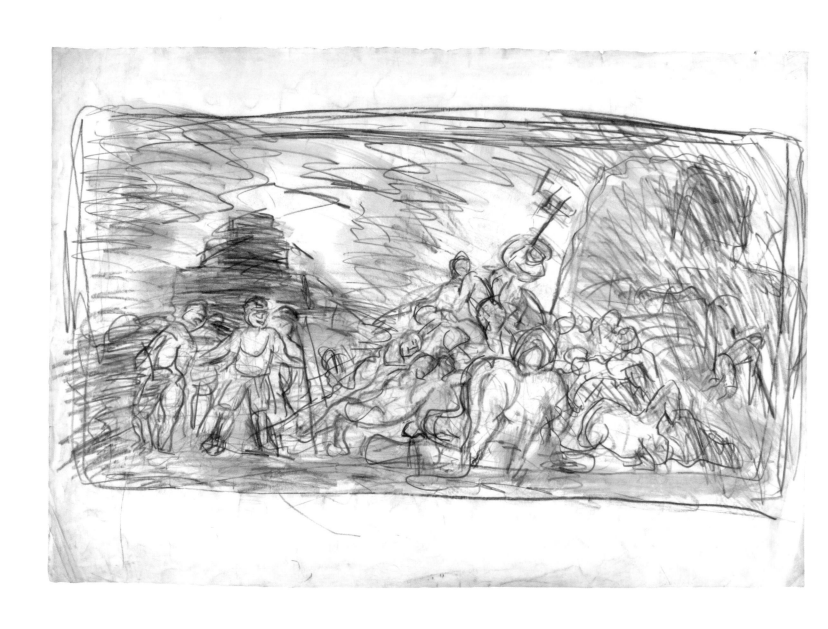

38 | *From Goya: Sketch for Summer or Harvesting*

Coloured chalks on paper · 56 × 81.2 cm

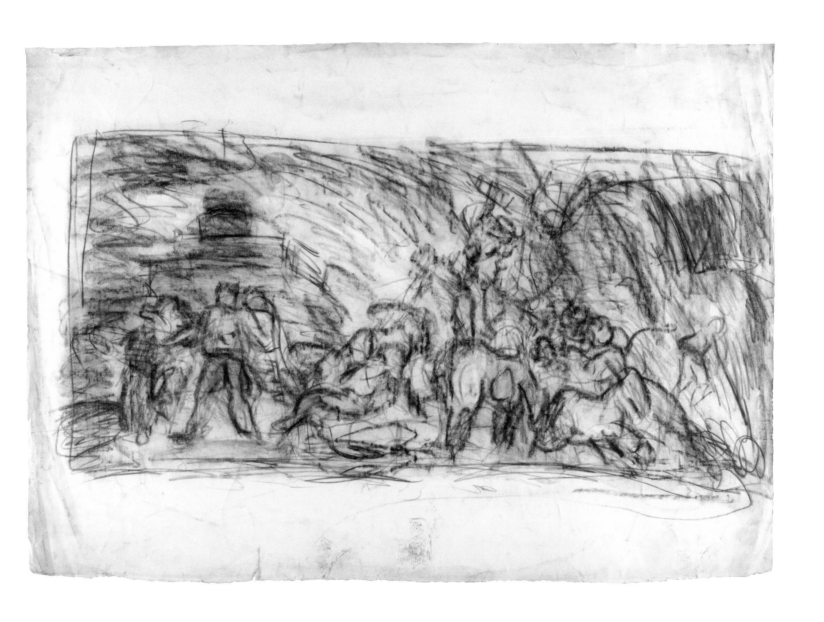

39 | *From Goya: Sketch for Summer or Harvesting* (2)
Black chalk on paper · 56 × 81.5 cm

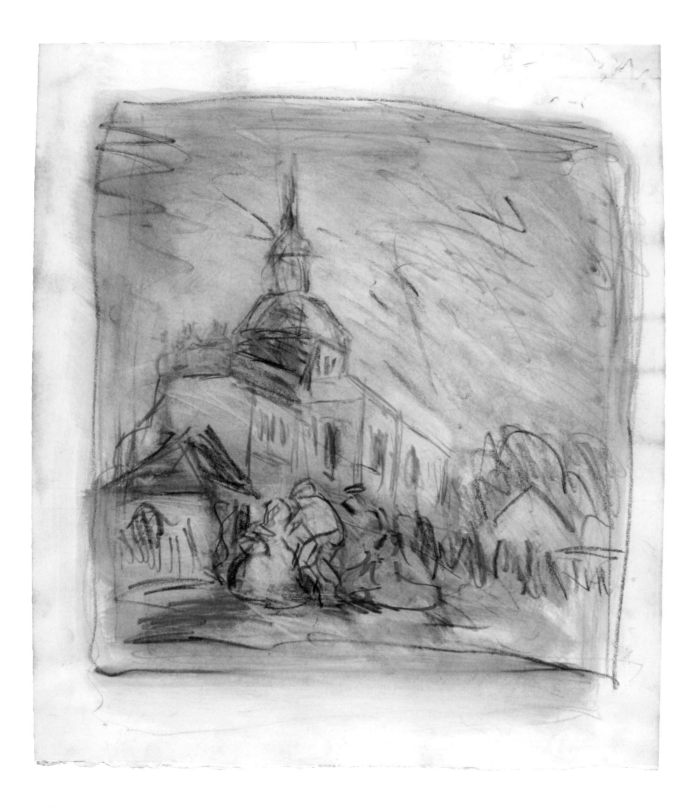

40 | *From Goya: The Hermitage at San Isidro*

Coloured chalks on paper · 54.2 × 48.3 cm

41 | *From Goya: The Meadow of San Isidro*
Coloured chalks on paper · 55.6 × 81.2 cm

42 | *From Goya: Making Shot in the Sierra de Tardienta*

Coloured chalks on paper · 42 × 59.5 cm

43 | *From Goya: Making Powder in the Sierra de Tardienta*
Coloured chalks on paper · 42 × 59.5 cm

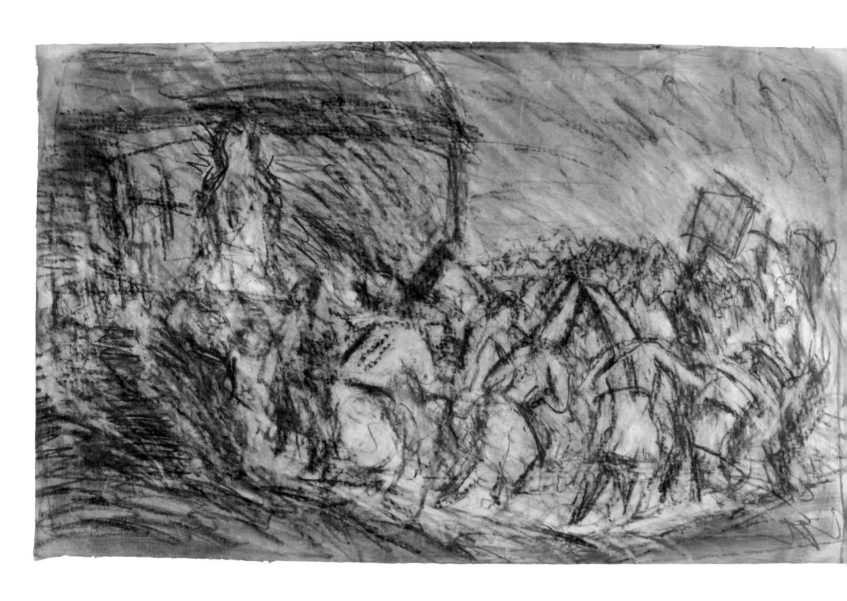

44 | *From Goya: Procession of Flagellants*

Black and coloured chalks on paper · 45.5 × 74.7 cm

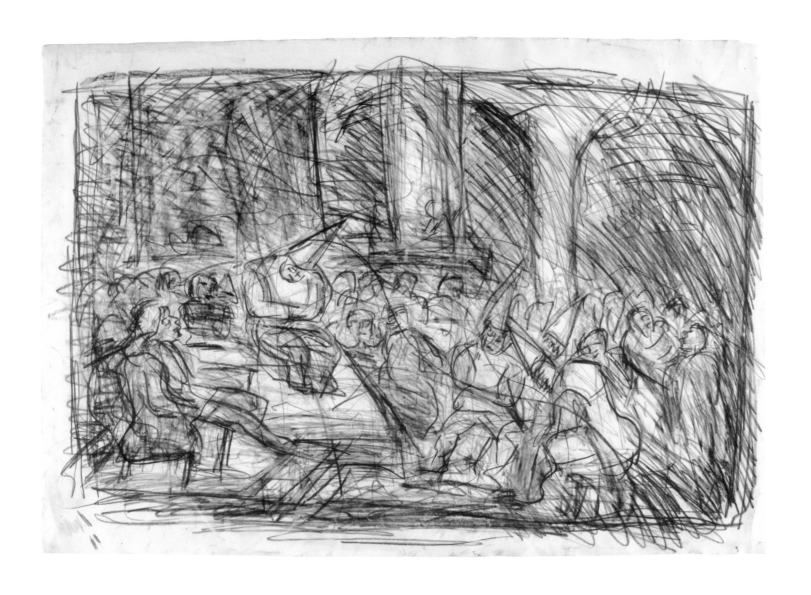

45 | *From Goya: 'Auto de Fe' of the Inquisition*
Charcoal on paper · 55.5 × 81 cm · Private collection

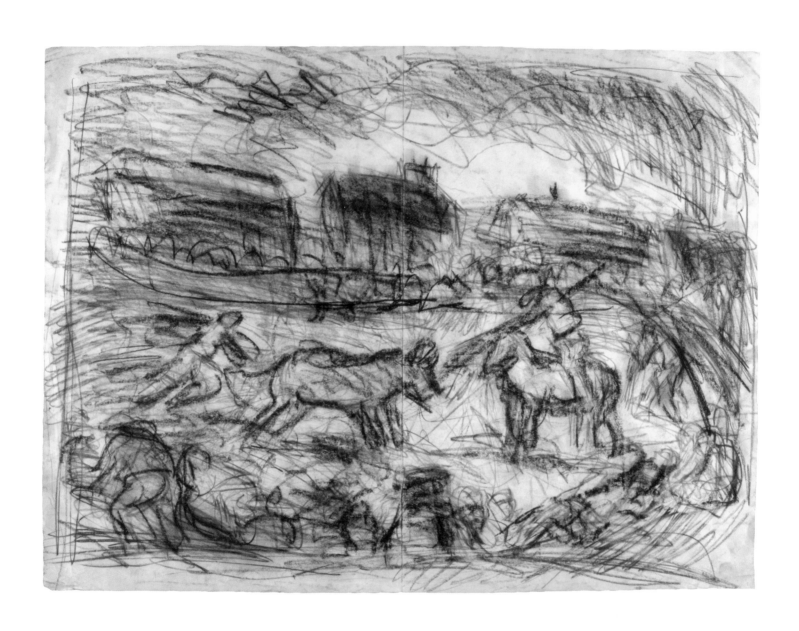

46 | *From Goya: Bullfight in a Village*

Black chalk on paper · 56 × 76 cm

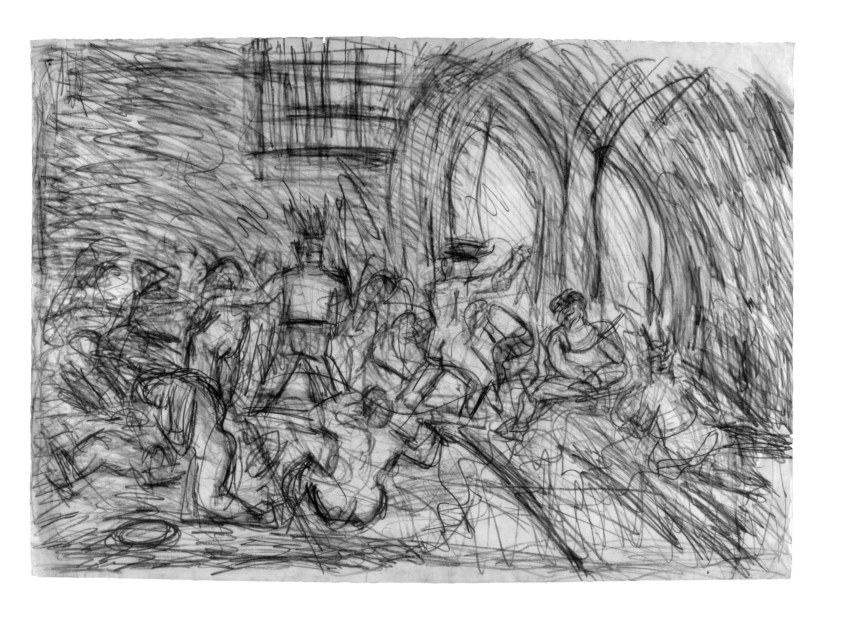

47 | *From Goya: The Madhouse*
Black chalk on paper · 55.7 × 81.2 cm

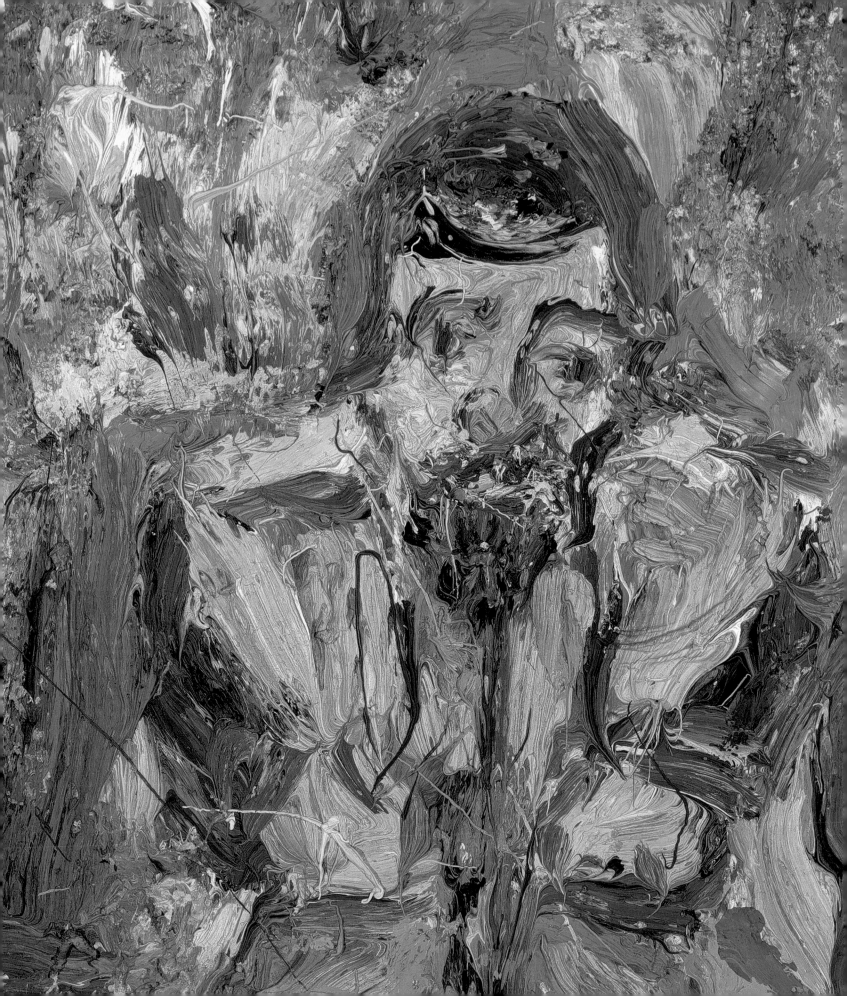

Leon Kossoff: Drawing From Goya *Juliet Wilson-Bareau*

Why, when the exhibition of Goya's small paintings came to the Royal Academy in 1994, did Leon Kossoff feel an immediate, intimate rapport with the Spanish artist and his work?[1] One explanation may be that from the time of his solo childhood visits to the National Gallery, Kossoff had been excited by the paintings of Rembrandt. For Goya too, the Dutch master was an iconic figure, although in eighteenth- and early nineteenth-century Spain, Rembrandt's work was principally known through prints. Kossoff too had been profoundly impressed by Velázquez, Goya's acknowledged master. Some 20 years ago, working from reproductions, he made two small paintings [cats 4–5] after Velázquez's moving portraits of Philip IV's dwarfs, *Francisco Lezcano* [fig. 8], the so-called '*Child of Vallecas*',[2] and *Don Sebastián de Morra* [fig. 9]. In the National Gallery, Kossoff has made drawings from Velázquez's *Christ after the Flagellation contemplated by the Christian Soul* [cat. 37], and at Apsley House he saw the celebrated *Water-Seller of Seville*, and was also drawn there to Goya's life-size yet little-known equestrian portrait of the Duke of Wellington.[3] But Velázquez has always remained something of an enigma for Kossoff, aloof and difficult to penetrate despite the splendour of his compositions and the ravishing immediacy of his brushwork.[4]

In his response to Poussin, Kossoff claims no particular interest in the subject matter as such and responds to something he has come to recognise within himself, to the emotion generated by Poussin's compositions and their execution. With Goya he is attuned to the subjects represented because he sees them as something experienced visually by the artist, and responds to the directness with which they are painted: genre scenes for the tapestry cartoons of the 1780s [figs 28–9], vivid depictions of guerrilla activity during the Spanish War of Independence [figs 30–31], and above all the four extraordinary images on panel at the Academy of San Fernando [figs 14–15 and 32–33]. Kossoff has said that he feels on more familiar terms with Goya than with Poussin because what Goya himself experienced 'is more of our own time', and because he was able to penetrate his subjects with such accuracy, and paint with such directness and freedom. He remains relatively unmoved and unconcerned by the series of small oils on tinplate, in which Goya first began painting for himself without the constraints of a commission. Art historians are excited by this group of works that followed the illness which left Goya stone deaf and encouraged him to turn to works of the imagination, though always based on the reality of things seen. Of the famous *Yard with Lunatics* (Meadows Museum, Dallas) from this series, a pre-figuration of the San Fernando *Madhouse* [fig. 15], Goya himself wrote that it was 'a scene I once saw in Saragossa', but for Kossoff it does not have the sense of authentic experience that he finds so overwhelming in the Academy panels. Similarly, while he appreciates the series of witchcraft scenes from the late 1790s (such as *A Scene from 'The Forcibly Bewitched'*, NG 1472], with their wonderfully observed figures, they too fall outside the category of 'real life' experience.

Goya was a late developer and had to work hard to find his way forward, opening up his style to new developments and finding the means to represent an increasingly complex understanding of the world. The relationship between the earlier series of small paintings on tin and the later panels is reflected in the progression between the earlier and later prints in his different sets of etchings. In each series of prints – 80 or more in the *Caprichos* and the *Disasters of War*, fewer in the bullfights and the

unfinished *Disparates* – the plates Goya etched first are generally filled with small figures seen in rather empty, airy settings.[5] As each series develops, the artist's etching technique becomes more assured and idiosyncratic. At the same time, it is almost as if the images rooted in his memory and seen in so many of his drawings take control, and begin to people his plates with scenes and figures of extraordinary vividness and pathos, often seen in alarming close-up.

Baudelaire wrote of the caricatures in *Los Caprichos* that Goya's great achievement was 'to make the monstrous credible',[6] through his mastery of the essentials of human gesture and expression, but Goya's grasp of 'body language' far outstrips particularities of grimace and gesture and facial expression. It conveys to the viewer an overwhelming sense of intimate contact with the artist's vision, of being in direct touch with the scene or figure that he represents. One of the catalysts for this awareness in Goya must lie in his early, intense scrutiny of the art of Velázquez, and particularly his representations of Philip IV's dwarfs. For his very first series of prints, etched in 1778, Goya chose to portray some of Velázquez's greatest works that had been hung in the new Royal Palace in Madrid. Goya's grasp of technique was insufficient at that stage to enable him to produce his intended complete portfolio of etchings after Velázquez, but he published eleven prints, including three of Velázquez's portraits of court buffoons or dwarfs [see fig. 10]. One of these, the portrait of *Don Sebastián de Morra* [fig. 9] also inspired Kossoff [cat. 4], while Goya anticipated Kossoff's copy after *Francisco Lezcano* [cat. 5] in a red crayon drawing and an unpublished etching.[7]

Kossoff's paintings after the two dwarfs by Velázquez, done from reproductions, succeed in recreating to a remarkable degree the essence of the originals. In his free interpretation of the '*Child of Vallecas*' or *Francisco Lezcano* [cat. 5] broad, swirling brushstrokes emphasise the tilt of the head and the circling rhythm of the arms, and create a sense of the figure rocking itself, as a real child will do for comfort. The dark, rocky background in Velázquez's painting no longer opens onto the distant, magical landscape of the *sierra*: flashes of white in the turbulent blue-grey pigment that swarms towards the figure suggest a lost radiance eliminated from the unlit head, now sunk in its blind, internal reverie.

Velázquez's portrait of *Don Sebastián de Morra* [fig. 9] is very different in character: the sitter is not perched

72

Fig. 8 · Diego Velázquez (1599–1660) *Francisco Lezcano*, 1638–40 Oil on canvas · 107 × 83 cm Museo Nacional del Prado, Madrid (1204)

Fig. 9 · Diego Velázquez (1599–1660) *Don Sebastián de Morra*, 1643–5 Oil on canvas · 107 × 82 cm Museo Nacional del Prado, Madrid (1282)

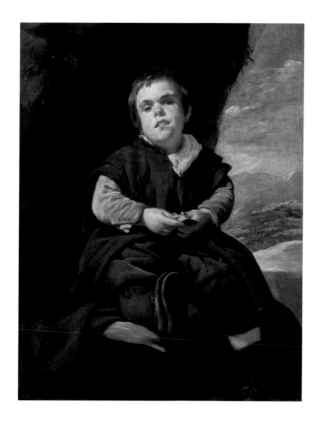

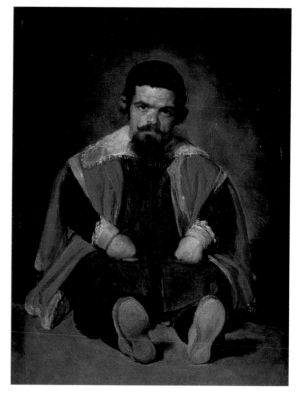

sideways on a rock or mound, but sits four-square on the ground, both fists tucked into his groin, and the soles of his shoes turned up towards the viewer, so that they emphasise the short legs seen in abrupt perspective. Velázquez does not introduce the same sense of languorous sadness as in the *'Child of Vallecas'*, but Kossoff [cat. 4] counters the almost unbearable, frontal thrust of the figure by skewing him sideways, and by softening and lowering the gaze that engages the viewer of Velázquez's portrait so disturbingly directly [fig. 9]. The eyes are now shielded, the moustache drooping, and the high contrast of red and green is muted and toned down. The figure is literally weighed down by the heavily charged brushstrokes that also indicate an undefined and claustrophobic setting. The downward thrust of the drab green jerkin seems to pin the figure to the ground, while dribbles of paint increase the sense of a creature subjected to an almost physical battering. Curiously, this has a resonance with a technique Goya used deliberately in his prints, where with a blunt tool he would 'batter' the face of a victim of the Inquisition. In Kossoff's depiction of *Don Sebastián de Morra*, he deliberately emphasises the sense of a figure locked within his body, and creates an image of human tragedy more generalised than that of

Velázquez's powerfully individualised and naturalistic, less overtly emotional image.

This attentiveness to the precise meanings generated by gesture, pose and gaze touches on a central mystery of art: the way in which the 'sense' – the creative intention and the physical nature – of an artist's work is transmitted and experienced mentally and spiritually but also physically, in its reverberation within the spectator's own body. In trying to express to Kossoff my understanding of the quality of a figure or figures in a history or genre scene or in a portrait, the construction of the composition, and the impact of the complete work on the viewer, I used the term 'body language', and Kossoff instantly responded with the phrase 'body of paint'. This seems to encapsulate his own striving to understand, and create for himself, that mysterious union of form and content, the artistic vision that must be expressed in layers of paint, and may also be conveyed in marks drawn on paper or through lines cut or bitten into a metal plate.

Kossoff has said of Goya that the artist haunts him, that he 'touched a nerve', a phrase that also suggests a physical as well as an emotional transmission of 'the space in the painter's mind'. Kossoff acknowledges in himself – and one sees the process clearly in the late work of such artists as Poussin, Rembrandt, Goya, Degas and Cézanne – the need to go on working in order to open up areas of the self that remain unknown, untested and untried. While Kossoff is adamant that the possibility of being influenced by other artists does not exist when he works in his studio, he welcomes their incitement to explore his own visual experiences in new ways, and in Goya he finds the encouragement to paint with greater freedom. Goya's late works are 'new' creations of the artist's mind, for which his increasingly tremulous hand invented new ways of mark-making to capture what he wished to record, in sitters for their portraits or in images of the fair at Bordeaux, or the haunting, half-remembered images of madmen.[8]

That the 'lesson' of Goya is still relevant may be seen in the recent transformations of Kossoff's painting. Partly in response to material alterations to the paints he uses, but also in pursuit of a new breadth and freedom that now seems to liberate his brush, Kossoff has adopted softer tones and textures, and a gentler fusion of figures and their surroundings [cat. 3]. The complex panels have become less heavily encrusted, more transcendentally

73

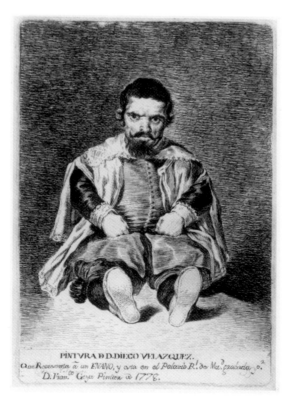

Fig. 10 · Francisco de Goya (1746–1828)
From Velázquez: Don Sebastián de Morra, 1778
Etching · 42.8 × 31.4 cm
Whereabouts unknown

luminous, more tranquil and even light-hearted, and one can point to parallels with a group of oil-sketches [see figs 28–9] that Goya made as preparation for tapestries. Painted in the mid 1780s, Goya's designs reveal the influence of French Rococo art, with its light, delicate colours and often playful subject matter. Of these Goya sketches that Kossoff finds 'so tender and so beautiful', he feels that they have the ring of things seen and experienced, and speculates that besides having an extraordinary visual memory, Goya must have made studies from life in order to be able to capture scenes that are somehow related to Kossoff's own recent, closely 'observed' paintings of urban scenes [cat. 2].

From the earlier series of the 'Four Seasons',[9] Kossoff was particularly drawn to the oil-sketch for *Summer* or *Harvesting* [fig. 29] and responded to it in several drawings, two of which are seen here [cats 38–9]. Goya's frieze-like composition shows groups of peasants taking a break from their labours with great bales and stacks of straw; they stand around or recline and rest on the straw. Two drawings by Kossoff explore the rhythms of the composition. One in black and grey crayon [cat. 39] appears deliberately wild and confused, as the artist's hand and eye chase through the scene, seeking to capture its rhythms, as if impelled forward by the vitality of the figures. In the other [cat. 38], the less agitated drawing is tempered and enlivened with colours that capture the luminous and playful ease of the scene. In both, Kossoff renders with differing emphasis the frontal figure of a drunken peasant, legs and arms outstretched in a pose he recognises as one of Goya's leitmotifs.

From the next group of sketches, Goya had only time to paint one full-scale tapestry cartoon before the project was brought to a halt by the death of King Carlos III. The sketches are perhaps the most enchanting that he ever painted,[10] and they illustrate Madrid's great annual festival, still celebrated today on 15 May, the feast of San Isidro, the city's patron saint. In one, Goya shows a crowd of people queuing at the saint's little hermitage for access to the holy spring, while a young man holding a jug offers a glass to a seated girl. With a few impulsive strokes [cat. 40], Kossoff conveys the caring urgency of the youth's attentions to the young woman, beneath the dome and lantern of the pretty, neo-classical hermitage.

The most celebrated view in this series is that of the 'pradera' that lies beside the river, the *Meadow of San Isidro*

[fig. 28]. In the almost bare foreground, seen as if springing from the pages of a book, young people gossip, flirt and drink, while crowds of people progress over the meadow down below under the watchful eye of uniformed guards, for the festival was also known for its unruly aspects seen in the sketch of a drunken picnic. In Kossoff's drawing [cat. 41] the whole scene is contained within diagonals that bring the city, surmounted by the great dome of San Francisco el Grande, into an even more intimate relationship with the slopes below the hermitage, while looping, curving strokes animate the space and lock the scene in celebratory mode.

This essentially eighteenth-century idyll was swept away by Napoleon's invasion of Spain and the Spanish War of Independence against the French. On 2 May 1808, the people of Madrid turned against the French troops and fighting in the streets led to executions on the following day. This sparked a conflict that raged for the next five years. Goya, who by this time was 62 and stone deaf, left the relative safety of Madrid and travelled to Saragossa, the capital of his native province of Aragon. A French siege had just been lifted, and Goya was invited to go 'in order', as he expressed it in a letter, 'to see and examine the ruins of that city, with the idea that I should paint the glorious deeds of its inhabitants'.[11] The story conveys something of the urgency of Goya's response to contemporary events, and his sense of passionate involvement in the fate of Aragon and its people. In 1810 he began work on a series of etchings to illustrate what he called the 'Fatal consequences of the bloody war in Spain against Bonaparte'.[12]

It was probably this journey that inspired the *Making Powder* [fig. 30] and the *Making Shot in the Sierra de Tardienta* [fig. 31], two small scenes that showed guerrillas engaged in their dangerous, clandestine tasks in the mountains to the north of Saragossa. For Kossoff, who saw the panels in the Royal Academy in 1994, these powerful works came 'close to Courbet' and evoked early Cézanne. They seemed to Kossoff almost to have been painted on the spot or at least to have been based on sketches drawn from life. While his own drawings [cats 42–3], broadly brushed and washed, explode with light rather than emphasise the dark intensity of Goya's little paintings, he dramatises their structure, their colour, and the sense of urgent purpose in the figure groups.

And so to the series of Goya's paintings that have

moved Kossoff more than any others: the four panels that were among the artist's own most highly prized works, and bequeathed to the Academy of San Fernando in Madrid less than 10 years after Goya's death [figs 14–15 and 32–33].[13] The complexity and emotional force of these four paintings inspired Kossoff to make drawing after drawing [cats 43–46], using black and grey crayons sometimes enlivened with colour. Goya's scenes symbolise aspects of contemporary life in Spain, with a glance toward a darker past. If painted, as they probably were, before 1812, they were created during the war, when Goya and his liberal friends were torn between sympathy for the values of the Enlightenment that had come to Spain from France, and loyalty to their country in the face of French aggression. At this time, about 1810–12, Goya painted a full-length portrait of a remarkable intellectual figure, Juan Antonio Llorente (Museu de Arte de São Paulo Assis Chateaubriand), who had been commissioned by the French 'Intruder King' Joseph I to write a history of the Inquisition in Spain. Goya would certainly have had conversations with Llorente, discussed his views and listened to the evidence compiled by this remarkable, reforming church historian.[14] Two of the San Fernando paintings were based, to some extent, on what Goya learnt from his sitter and are closely linked to a celebrated album of drawings by Goya that includes victims of the Inquisition.[15]

Fig. 11 · *Goya, Drawings from the Prado*, pp.97–8 Introduction by André Malraux, translated by Edward Saville-West, Horizon 1947

To prepare for his sessions with Goya's paintings, Kossoff habitually sketched from reproductions of these drawings before he left for the Royal Academy. He chose these powerful and expressive subjects to get his hand and mind's eye working together, in anticipation of the large-scale drawings he would make directly from the

paintings. Two are reproduced here, taken from facing pages in the book [fig. 11]. The first shows an imaginary depiction of Galileo Galilei, tortured 'For discovering the movement of the earth' [fig. 12]. On the facing page, an anonymous victim in a cell bears Goya's grimly ironic caption: 'Not everyone knows about this'.[16]

Working quickly in black chalk, occasionally smudged to simulate the wash on Goya's drawings, Kossoff captures the essential rhythms of the images, the lines of force that express the hopelessness of the victims and create their emotional impact. In the drawings made at the Royal Academy, he time and again confronted the four San Fernando panels, seeking to grasp the message held in these powerful compositions. The rapt attention of the crowd at a *Bullfight in a Village* [fig. 33], in which the lithe and wary beast confronts an array of fighters, was perhaps for Goya an allegory of life and death in Spain, couched in the language of a sport he knew, loved and depicted. The bull is dangerous and may wreak grievous harm on his tormentors, but in the end, inevitably, he will be killed. In his mature compositions, Goya adopted a circular movement, as if to suggest that each work embraces a whole world of human action and emotion. This is echoed in the whirling linear structure of Kossoff's drawings of the *Bullfight*. In one [cat. 46], the protagonists in the improvised ring almost meld with the spectators in the foreground, light glows in the agitated sky and the urgent hatching at the limits of the composition flies out beyond roughly drawn border lines to left and right.

The drawings from Goya's *Procession of Flagellants* [fig. 14] explore the forward movement of the flagellating penitents, which transforms into a fanatical, surging force as they weave and sway ahead of the image of the Virgin held aloft by her devotees [cat. 44]. Some of the drawings suggest a spacious and lyrical religious ecstasy; in others, as here, participants, onlookers and architecture are compressed into an agitated shallow relief of repeated, echoing lines. These generate a movement that turns back on itself, as if there is no issue for this struggling, self-harming, perhaps self-deluding throng. The textures are coarse, and the crayon work produces grainy bumps that resemble wounds on the half-naked figures.

The tall, pointed *corozas* worn by these penitents also appear on the subjugated 'penitents' before the Inquisitors conducting an *Auto de Fe* [fig. 32]. On the platform, a cowed and humiliated victim listens as his

76

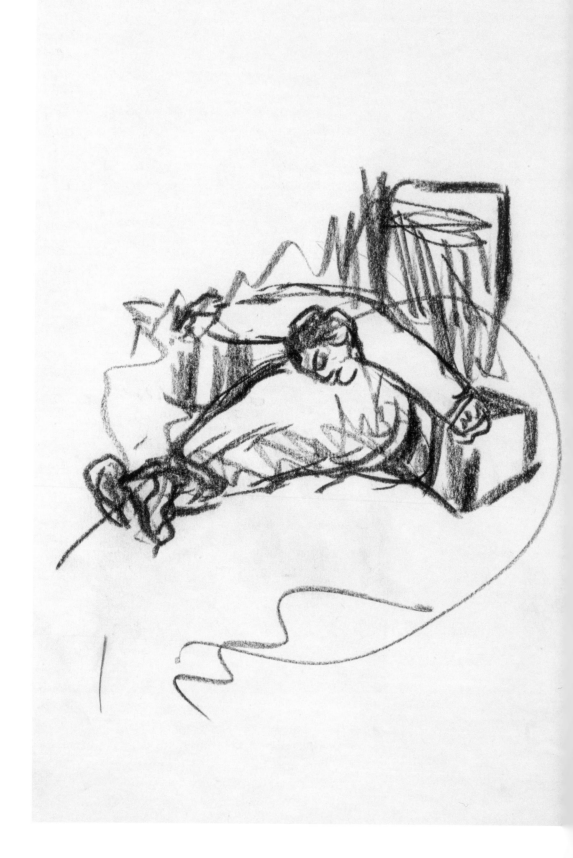

Fig. 12 · *From Goya: Album C (94)*
'For discovering the movement of the earth'
Charcoal on paper · 21 × 29.6 cm

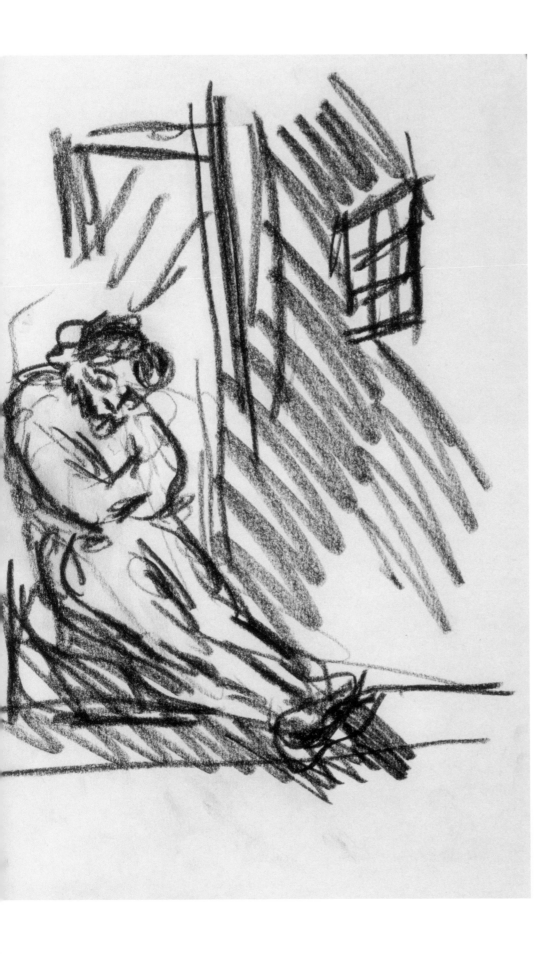

Fig. 13 · *From Goya: Album C* (95)
'Not everyone knows about this'
Charcoal on paper · 21 × 29.6 cm

78

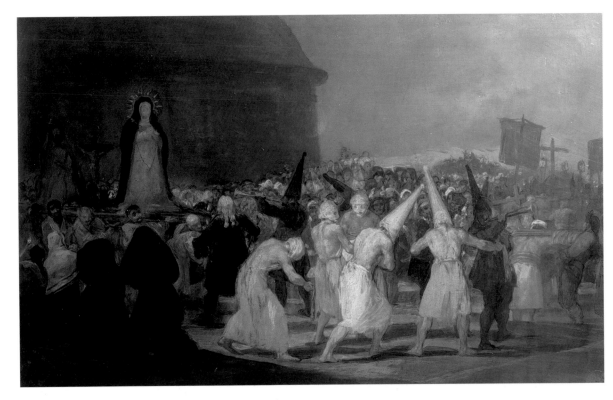

Fig. 14 · Francisco de Goya (1746–1828) *Procession of Flagellants*, about 1815–19
Oil on panel · 46 × 73 cm · Museo de la Real Academia de Bellas Artes de San Fernando, Madrid

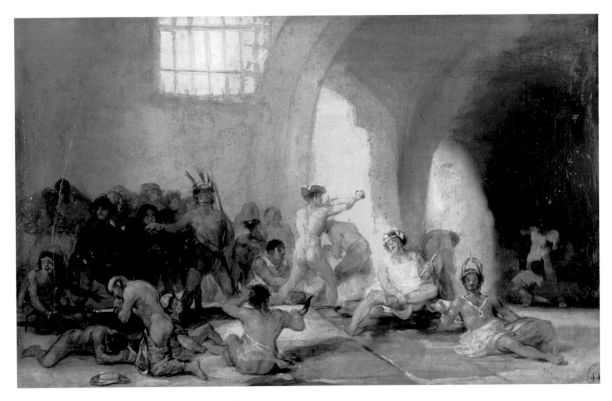

Fig. 15 · Francisco de Goya (1746–1828) *The Madhouse*, about 1815–19
Oil on panel · 45 × 72 cm · Museo de la Real Academia de Bellas Artes de San Fernando, Madrid

crimes are declaimed or his sentence read out, while others, trembling, await their turn in the foreground. In a magisterial interpretation, perhaps the most impressive of a dozen or so sheets, Kossoff captures the 'architecture of power' and the 'power of fear' in Goya's extraordinary composition [cat. 45]. The victim is caught in the process of his trial, and becomes part of the Inquisitorial construct, the inhuman treatment and abuse of power that were anathema to Goya's liberal views. The dark border that surrounds Kossoff's vision of the scene suggests that light – enlightenment – lies outside the confines of this dreadful place, and that there is no escape from a process that will roll on until all its 'enemies' are accounted for. Goya's friends had suffered, or would soon suffer, for their belief in the principles of the Enlightenment, if not those of Liberty, Equality and Fraternity. The symbolism of this composition could not be clearer, or its message more powerfully conveyed, and where Goya seized on particular expressions and body language of victims and their abusers, Kossoff sweeps all of them into his terrifying image of a hall of fear and shame.

The universal significance of Goya's masterpieces is underlined in his painting of a *Madhouse* [fig. 15]. The crazed figures that he chooses to portray reflect all sorts and conditions of men: from the 'ruler' with his crown and sceptre, the 'ecclesiastical dignitary' with his skeletal mitre, the 'commander' with his three-cornered hat, and the 'noble savage' in feathered headdress, whose hand is kissed devoutly by a 'devotee', to the 'murderer' who endlessly threatens his supine 'victim' with a knife, and the 'cuckold' in the centre, holding horns to his head. Here, too, Kossoff drew many sheets, in many different modes, seeking to understand the significance of the different elements in the composition – space and light, gesture and expression – and the threads that bind the whole together. In a powerful drawing in black and grey crayon [cat. 47], he emphasises the integration of figures and architecture, and the manic repetition of pose and gesture. Here, in the 'savage' standing beneath a square, barred window, is a very different and much harsher

version of the 'idiot' in Goya's sketch for *Summer* [fig. 29]. In some of Kossoff's drawings from the *Madhouse* the figures interact with each other and seem to strain towards the light. But in this interpretation there is no escape from the unyielding straightjacket of their minds.

Kossoff recognises in Goya's art a unique conjunction of darkness and light that the Spanish master experienced at one and the same time. The perceived struggle between the two perhaps explains the variety in interpretations of particular paintings. In the San Fernando panels he responds to their 'fresh view of the modern world', and feels that they must have been based on drawings of things actually seen by the artist. For Kossoff they have the immediate appeal of a direct visual experience, and he is touched by the subjects Goya chose to represent that 'have something to do with the life *we* lead'. For this reason, he finds the Academy panels much more vital and exciting than the Black Paintings, as if they, and not the later works, express Goya's last look at Spain before he moved to France at the end of his life.[17] But Kossoff also recognises the imaginative quality of Goya's images, and above all his capacity to reinvent himself throughout his life, to respond to new experiences, and boldly translate his subjects in terms of his own developing mastery, his own individual style. Goya has been criticised for his inability to draw 'correctly', but his grasp of the meaningful structure of a figure, the deeply felt significance of pose and gesture, and their expression through purely artistic means, renders literally correct description immaterial.

The obsessive repetition of drawings done at great speed over and over again from the same paintings is a measure of Kossoff's desire to engage with an artist who encourages him to work directly, to be bold, to take risks. It is also indicative of Kossoff's desire to share – and encourage others to share – in the experiences of a tireless creator always eager to express new things. An artist who, even during his final years, constantly invents and reinvents an art that in spite of its darkness Kossoff sees as 'essentially all about living and the joy of being alive'.

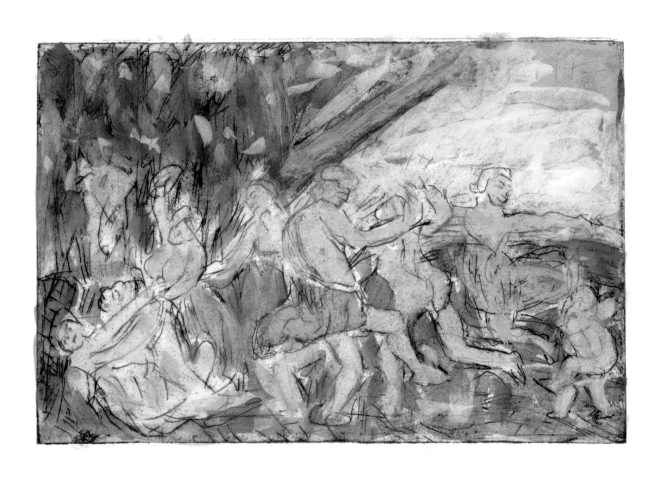

48 | *From Poussin: A Bacchanalian Revel before a Term (2)*

Hand coloured etching and drypoint · 29.4 × 40 cm · Private collection

IV · DRAWING FROM POUSSIN

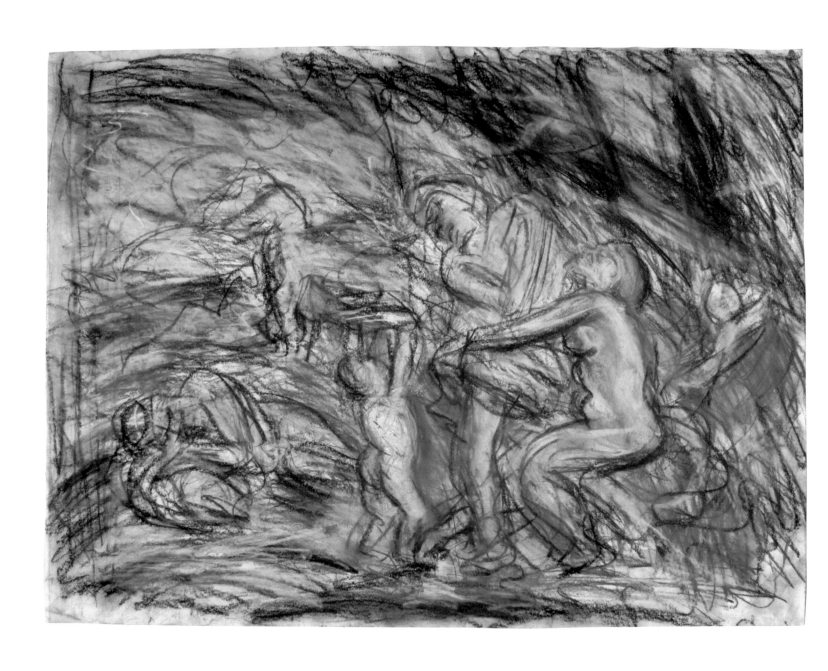

49 | *From Poussin: Cephalus and Aurora*
Pastel, charcoal and ink on paper · 57.8 × 74.9 cm

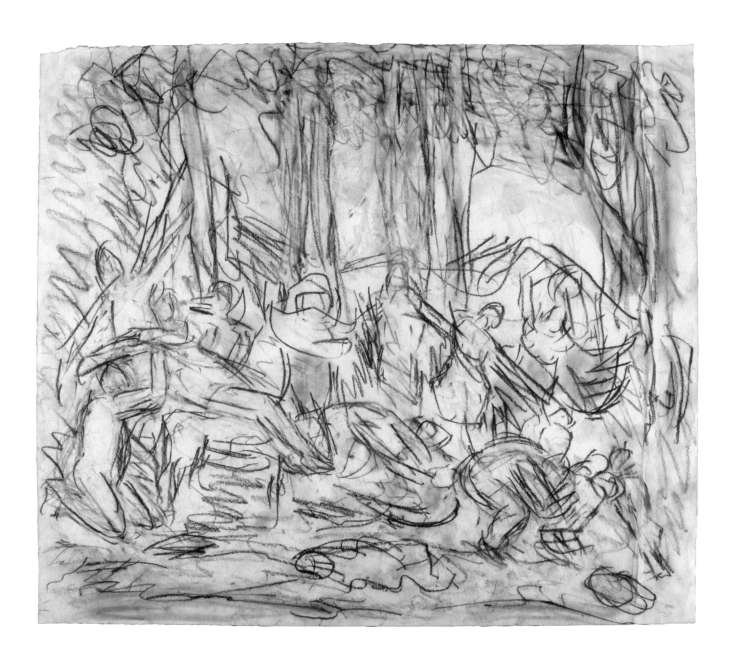

50 | *From Poussin: The Triumph of Pan*
Coloured chalks on paper · 51.2 × 59.4 cm

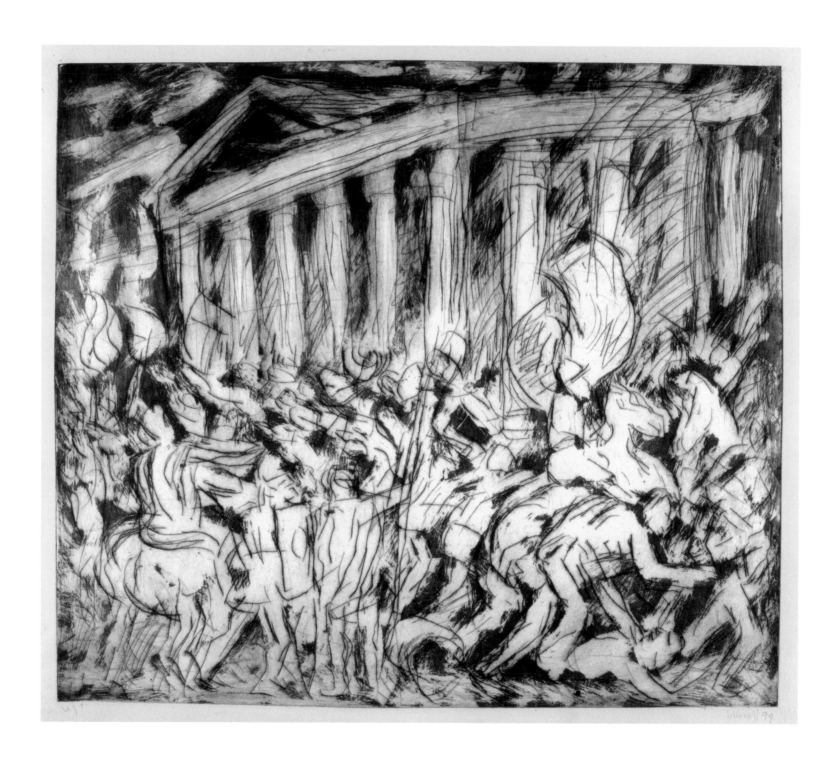

51 | *From Poussin: The Destruction and the Sack of the Temple of Jerusalem*
Etching and aquatint (unique print) · image 50 × 59.9 cm

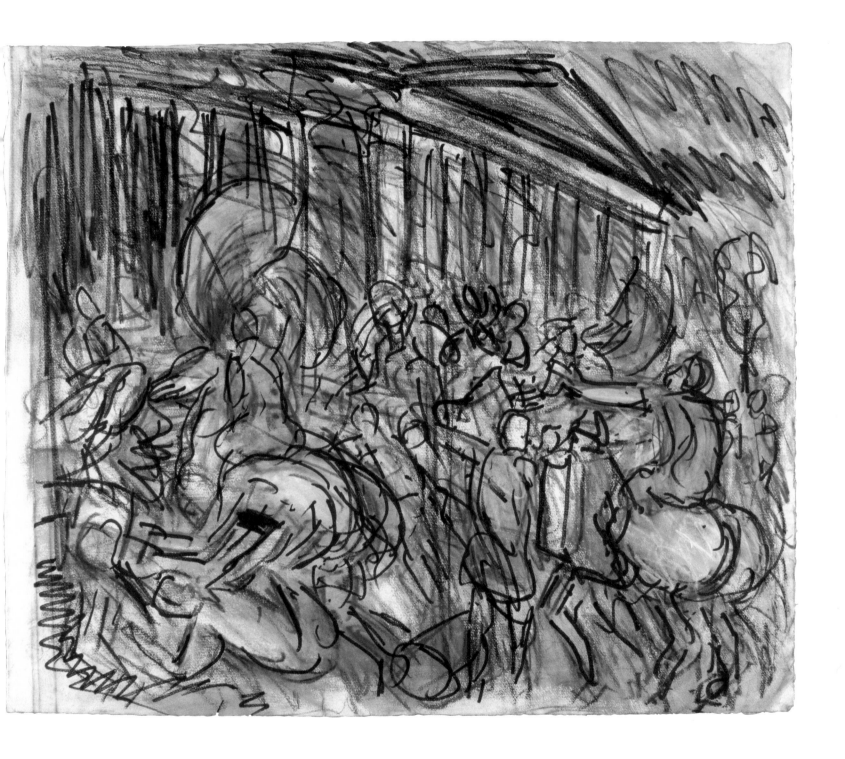

52 | *From Poussin: The Destruction and the Sack of the Temple of Jerusalem*
Coloured chalks and felt pen on paper · 56 × 66.5 cm

53 | *From Poussin: The Rape of the Sabines*
Black and white chalk on paper · 56 × 76.5 cm · Private collection

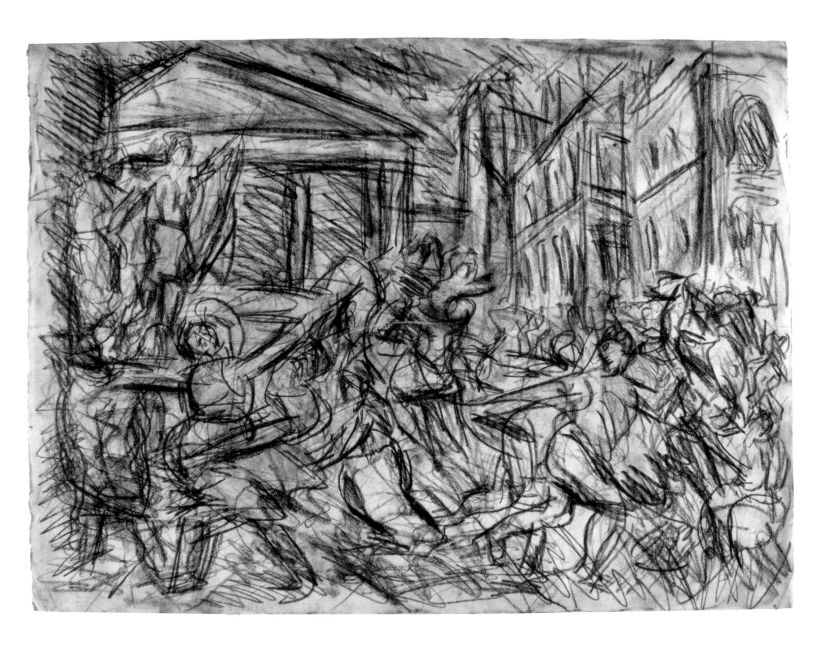

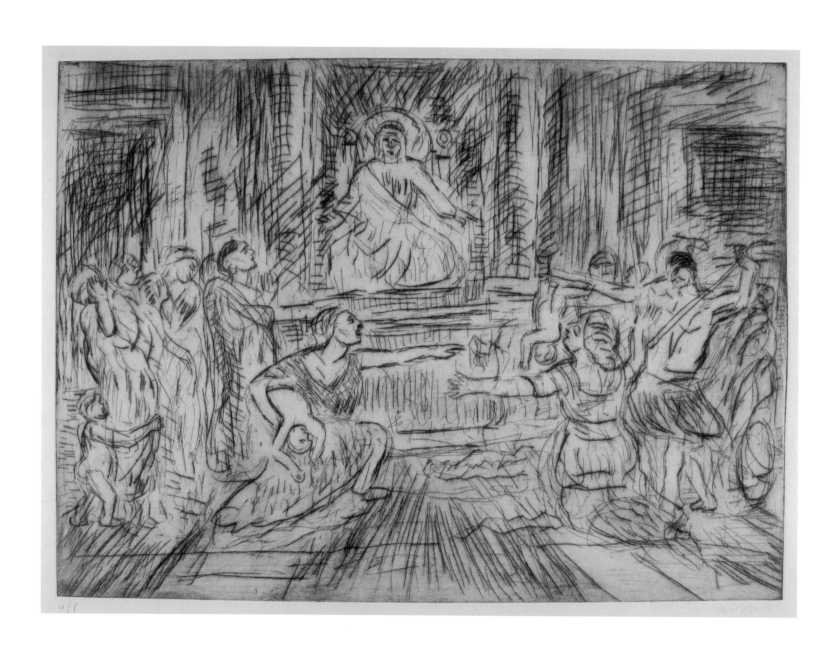

54 | *From Poussin: The Judgement of Solomon*
Etching (unique print) · image 42.8 × 59.5 cm

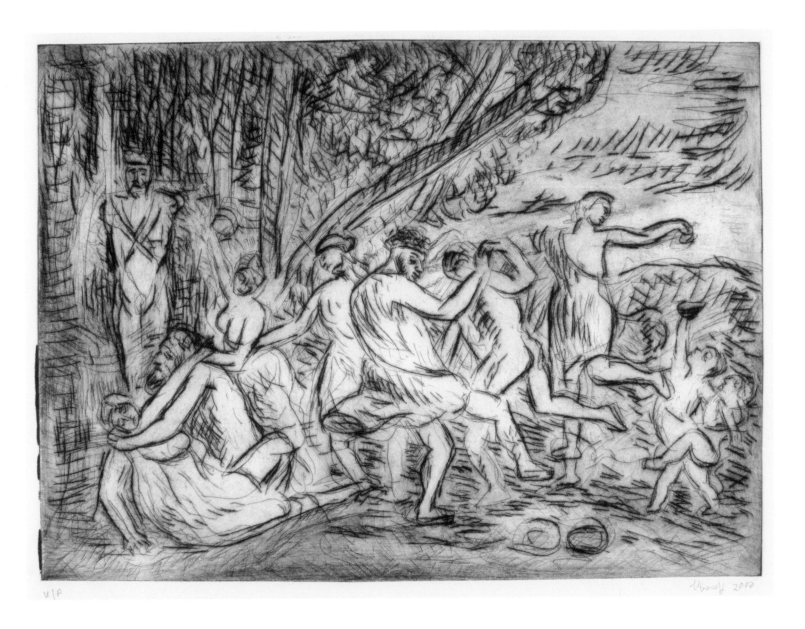

V/P

Kossoff 2000

55 | *From Poussin: A Bacchanalian Revel before a Term*
Etching (unique print) · image 40.8 × 57 cm

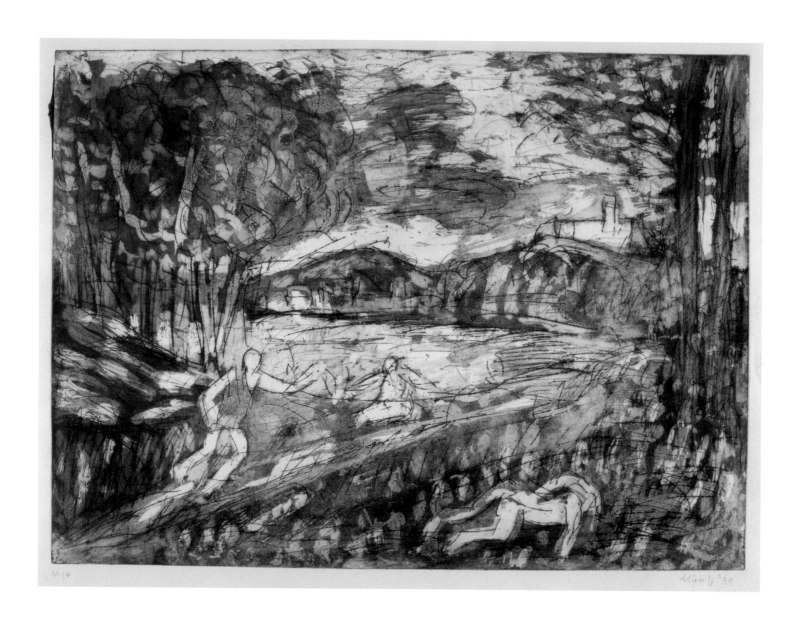

56 | *From Poussin: Landscape with a Man killed by a Snake*

Etching and aquatint (unique print) · image 42.5 × 58.9 cm

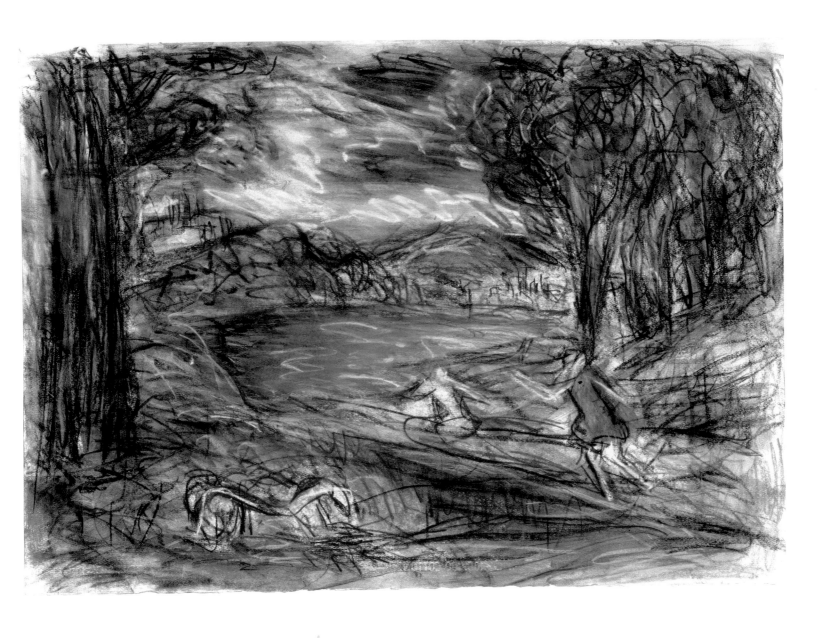

57 | *From Poussin: Landscape with a Man killed by a Snake* (2)
Charcoal and pastel on paper · 56.2 × 75.6 cm · Private collection

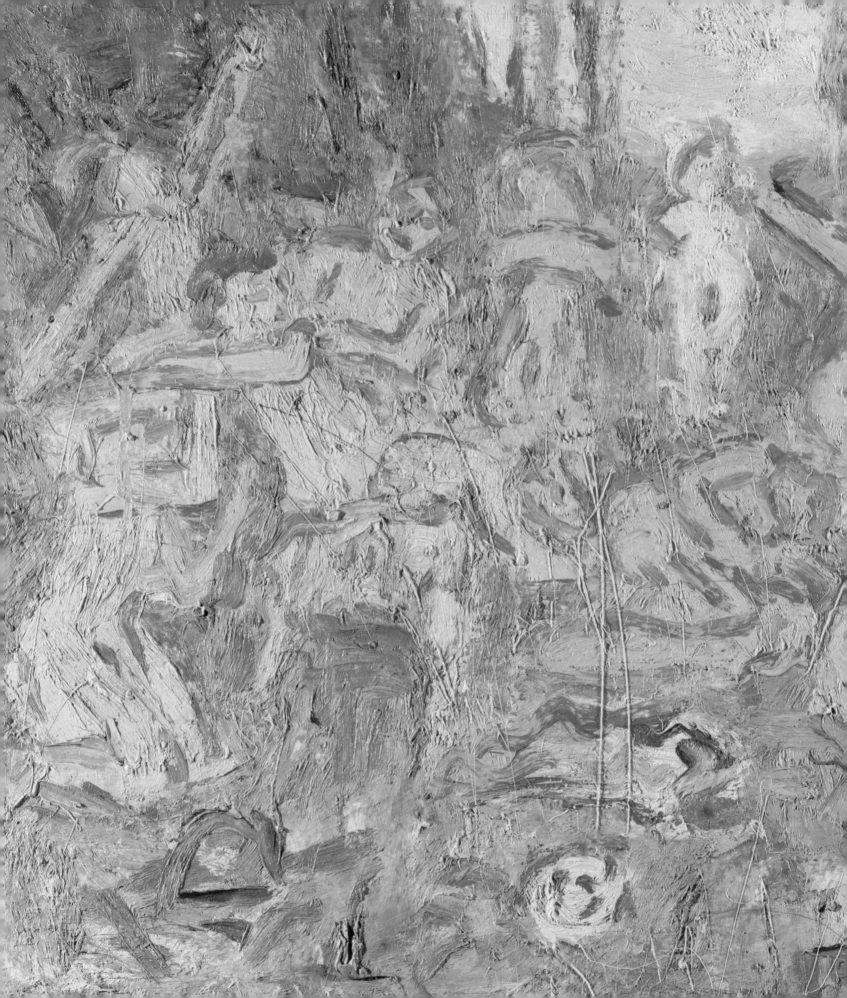

From Poussin *Philip Conisbee*

Leon Kossoff's early morning drawing sessions in the National Gallery and the Royal Academy have become somewhat legendary. One can imagine the tension: the solitary expectation, the early rising, the trip across town burdened with equipment, and then several hours of silent communion, or rather concentrated activity. There is never enough time alone in the galleries with the pictures, drawing in charcoal and pastel, or etching a zinc or copper plate, uninterrupted excepting perhaps the hum of a distant vacuum cleaner.

Kossoff has said that his first conscious experience of the art of Poussin was during the early 1960s, when he was attracted to the National Gallery's *Cephalus and Aurora* [fig. 21], and for all that he admired its formal qualities, he also recognised it as 'a painting about love'.[1] How often does art reveal its student? Suffused with golden light, *Cephalus and Aurora* is the quietest of the National Gallery's remarkable group of works by Poussin (it is not helped by a somewhat abraded condition), yet the principal group is powerfully eloquent. These figures from classical mythology act out an all-too-human moral dilemma, a story of love and of love denied, as Cephalus struggles to resist the amorous blandishments of Aurora, turning away from her with undeniable yearning and regret to contemplate the image of his true beloved, Procris. Kossoff revisited the picture in 1998, through a series of densely worked drawings that explore the weight, mass and chiaroscuro of the painting; the subtle additions of colour to the most resolved of these drawings brings an undeniable aura of sensuality [cat. 49]. The etchings from the same painting, quite different in feeling, capture the moral essence of the scene with incisive economy.

But Kossoff has drawn and etched from many Old

Masters.[2] Their work has provided a reference for a range of essentially independent works, above all drawings and prints (but there are also paintings, which provide a quite different experience for the viewer). In contrast with Poussin, we might almost expect Kossoff to be drawn to Rembrandt, and indeed it seems almost naturally predetermined that the first work to catch his attention as a boy on his first visits to the National Gallery was *A Woman bathing in a Stream (Hendrickje Stoffels?)* [fig. 25], as Kossoff has related: 'I remember feeling that I could learn to draw from this painting.'[3] It is as if Kossoff has been having an artistic dialogue with this picture, in all its rich impasto and its very particular palette, all his life [fig. 1]. *Ecce Homo* [fig. 27], at once a demonstrative work, but with an intensely internalised emotion, has also been the basis for several drawings [see cat. 24]. Is it the emotion of Rembrandt's scene, the extreme existential anguish of the situation, that was the attraction? Or the play of deep space and chiaroscuro, which so isolate the small, forlorn figure of Christ? The Dutch master's terrible *Blinding of Samson* [fig. 2], on loan for a time at the National Gallery in 1998, elicited an appropriately baroque and expressionist response from Kossoff: and what visual artist would not feel empathy with the struggling figure, whose eyes are being so brutally gouged? It seems often to me as much the matter – that is to say its emotional import – as the manner of a particular painting, that attracts Kossoff (if, that is, we can really separate the manner and the matter), although he has claimed it is the pictorial, rather than the thematic character of other artist's work that has attracted his attention.[4] Constable's *Salisbury Cathedral from the Meadows* [fig. 34] is a masterpiece by any standards, and there are analogies in his dark and tortured late handling with Kossoff's application of paint in his

[detail of cat. 6]

landscapes. But can we discount Kossoff's wartime childhood years, spent in the seclusion of East Anglia, or the resonance of the tragic implications of Constable's late works?

But Poussin? The French painter is, after all, at a sort of opposite aesthetic pole from his contemporary Rembrandt, and one might hardly immediately consider him a Kossoff artist, yet he has proved to be one of the London painter's most consistent inspirations. How different from Rembrandt is Poussin's classicism in the calculated planarity of the compositions, the precise articulation of space and the placing of figures and architectural elements; the richness and sensuous beauty of his colour, carefully bounded by its containing forms – and in the carefully controlled gesture and expression that mark his emotional narratives. Kossoff makes a Poussin, or a Rembrandt or a Constable, his own, because working from them they are subsumed into Kossoff's own distinctive manner. His drawings – and his prints, at least in the initial graphic phase, when they are scratched into the plate in front of the selected painting – have an impulsive, even impetuous, rhythmic feel, as his hand moves rapidly across the sheet or plate, now seizing a movement, a gesture, an expression, a play of light and shade, yet trying to keep the scale, proportion and effect of the whole. This is no Ruskinian approach to drawing, 'rejecting nothing, selecting nothing,' but an authentic and independent creative act *from* the chosen models: as much an interpretation of the source as, say, a drawing of Christchurch is from Hawksmoor's masterpiece in Spitalfields.

It is not always a successful process, and at the artist's house there are bulging drawers and several piles on the floor that contain the *disjecta membra* of his efforts. We are reminded that Kossoff is not easily satisfied as a draughtsman or as a painter – in so far as he would accept a distinction, for he has said 'Painting is drawing with paint,' and 'I think of everything I do as a form of drawing'.[5] He has often described the need to scrape off accumulations of pigment from earlier versions of his paintings, which are usually finished in one passionate session of work, when the image has not come right.[6] In his studio the scattered, scraped off paint seems the detritus of so many unresolved and abandoned emotional encounters. There must be a similar spontaneous physical engagement with the drawn and etched works,

and we can feel when the moment of engagement has been authentic and therefore successful.

After his initial encounter with *Cephalus and Aurora* [fig. 21], Kossoff was drawn back to Poussin by the exhibition mounted at the Royal Academy in 1995, and then over the next few years he returned to work again from the pictures in the National Gallery. This period of renewed interest in Poussin culminated in 1999 and 2000, when he was invited to make a series of drawings and prints from *Landscape with a Man killed by a Snake* [fig. 22], and from *Landscape with a Calm* which had been acquired recently by the J. Paul Getty Museum and was placed on deposit at the National Gallery so that Kossoff could work from it.

It is Poussin's powerfully emotional subjects, such as *Landscape with a Man Killed by a Snake* with its tragic theme, which seem closest to Kossoff's heart. A highly wrought charcoal and pastel drawing [cat. 57], and the etched plate, with its richly picturesque layers of aquatinted tone, so far pulled only in a unique proof [cat. 56], are among Kossoff's most successful from Poussin. Concentrating on the simplified forms of the three main protagonists – the dead man, the frightened man running and the alarmed woman – and the shadowed areas of the melancholy landscape, Kossoff captures the sinister and tragic intrusion into an otherwise idyllic world.

One of Kossoff's favourite works by Poussin is *The Judgement of Solomon* [fig. 24], a reproduction of which is pinned on his studio wall with his modest *musée imaginaire* of admired works by other masters [page 2]. Here is one of Poussin's most intense emotional dramas, rendered in a composition so rigorous that it would take a can opener to prise it apart. In the prints made from it [cat. 54] the etched lines act like lines of emotional force, vectors of emotion and counter-emotion that ricochet around the palace room signifying the scene's terrible desperation. Kossoff has found the perfect equivalent in line for the colouristic drama enacted by Poussin. Another kind of pictorial drama, of confusion and chaotic military action, is expressed in the drawings [cat. 52] and print [cat. 51] from the recently rediscovered *Destruction and Sack of the Temple of Jerusalem* [fig. 23], which was exhibited at the National Gallery in 1999. The confusion of battle is also conveyed brilliantly by line in Kossoff's earlier drawing from Poussin's *Rape of the*

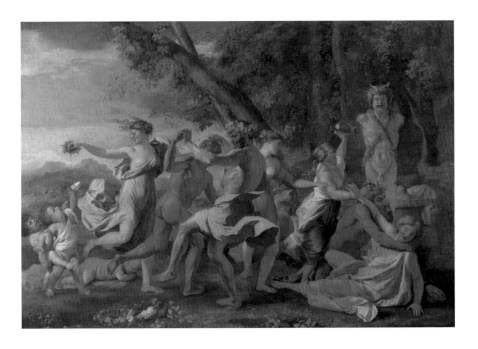

Fig. 16 · Nicolas Poussin (1594–1665) *A Bacchanalian Revel before a Term*, 1632–3
Oil on canvas · 98 × 142.8 cm · The National Gallery, London

Fig. 17 · Nicolas Poussin (1594–1665) *The Triumph of Pan*, 1636
Oil on canvas · 135.9 × 146 cm · The National Gallery, London
Bought with contributions from the National Heritage Memorial Fund and The Art Fund, 1982

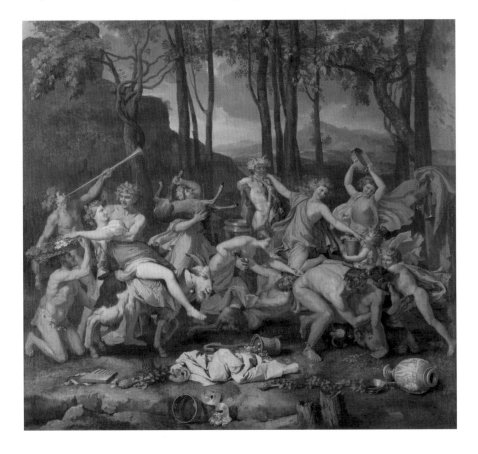

Sabines: this drawing [cat. 53] is one of series, and there are also several versions of a highly agitated print.

Kossoff responds with equal sensitivity to Poussin's bacchanalian subjects, above all the National Gallery's *Bacchanalian Revel Before a Term* [fig. 16] and *The Triumph of Pan* [fig. 17], from which he has also made a voluptuous oil painting [cat. 6]. The various drawn and etched variations on these subjects, from the *Bacchanalian Revel* [cats 48 and 55] and from the *Triumph* [cat. 50] convey a true Dionysian vitality. A frenzy of seemingly intuitive lines contributes to the movement of Kossoff's overall pictorial rhythms.

A London audience is especially familiar with Leon Kossoff's paintings of the city, and with his dark, emotionally charged, at times Walter Sickert-like interiors, occupied by the presence of a reclining model, a friend, or a family group. These works have evidently been executed with considerable speed and physical energy, with deep, passionately applied paint, with lines and grooves ploughed through a primordial chaos to bring form and image up to the light, and with a certain lyricism in the final assertive flourish of a surface skein. If the overall mood tends to be one of existential gloom, or is pervaded with the gnawing melancholy of the neglected neighbourhoods of any great city, there are moments of joy too: a bustling station forecourt on a sunny day [fig. 7], Christchurch Spitalfields [cat. 2] in the spring, the aura of a sensuous nude, a public swimming pool where we can almost hear the joyful shrieks of splashing children or a flower stand under Hungerford Bridge. Kossoff is not a great traveller, but nor does he need to be. His subject matter has always been his familiar London world, his personal trajectory from the East End to Willesden. The National Gallery, and its art, is no less a part of his London. He can experience almost the whole great tradition of European painting in these places, there joining the regions of imagination and emotion to those of quotidian reality.

95

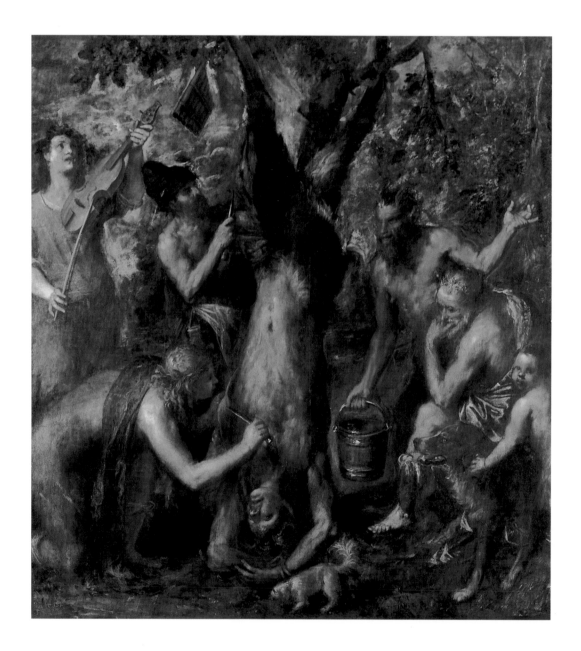

Fig. 18 · Titian (active about 1506; died 1576)
The Flaying of Marsyas, 1570–6
Oil on canvas · 212 × 207 cm
The Archbishop's Palace, Kromeríz (0107)

V · FROM PAINTINGS 97

Titian · Veronese · Poussin · Rembrandt
Goya · Constable · Degas

Fig. 19 · Paolo Veronese (probably 1528–1588)
The Consecration of Saint Nicholas, 1561–2
Oil on canvas · 282.6 × 170.8 cm
The National Gallery, London

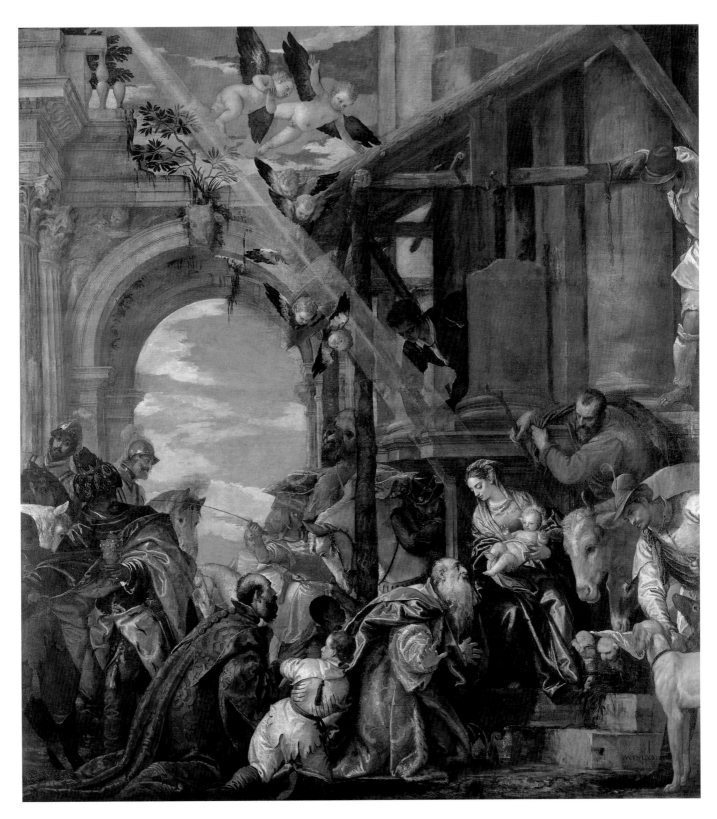

Fig. 20 · Paolo Veronese (probably 1528–1588)
The Adoration of the Kings, 1573
Oil on canvas · 355.6 × 320 cm
The National Gallery, London

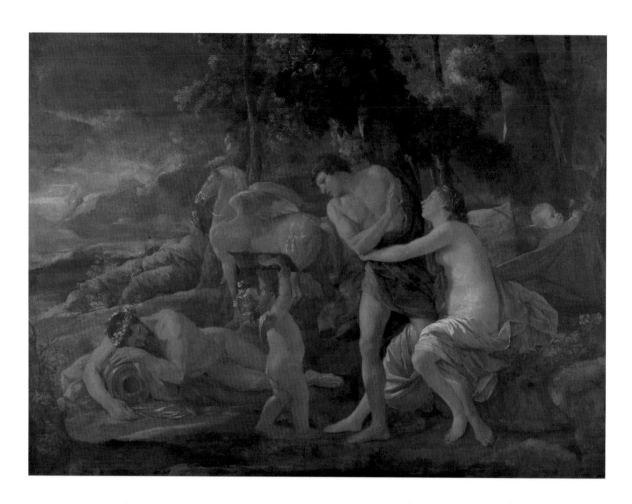

Fig. 21 · Nicolas Poussin (1594–1665)
Cephalus and Aurora, about 1630
Oil on canvas · 96.9 × 131.3 cm
The National Gallery, London
G.J. Cholmondely Bequest, 1831

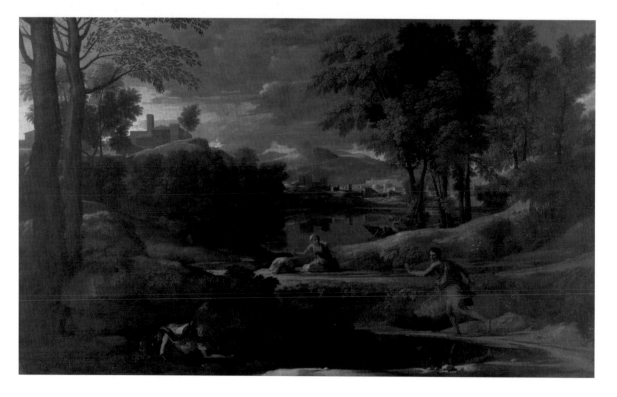

Fig. 22 · Nicolas Poussin (1594–1665)
Landscape with a Man killed by a Snake,
probably 1648
Oil on canvas · 118.2 × 197.8 cm
The National Gallery, London

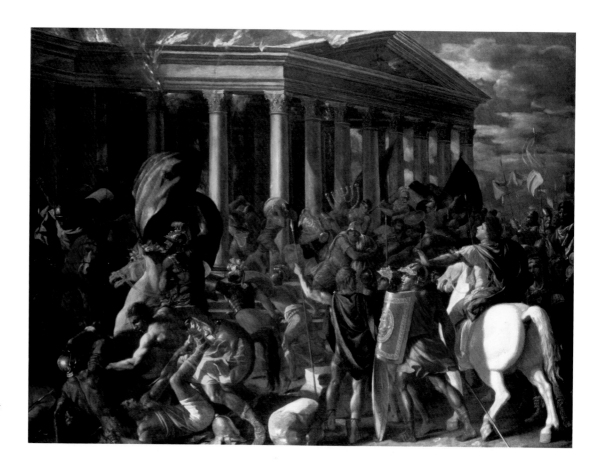

Fig. 23 · Nicolas Poussin (1594–1665)
The Destruction and the Sack of the Temple of Jerusalem, 1625–6
Oil on canvas · about 141 × 194 cm
Collection Israel Museum, Jerusalem · Gift of Yad Ha–Nadiv, in memory of Isaiah Berlin (B99.0001)

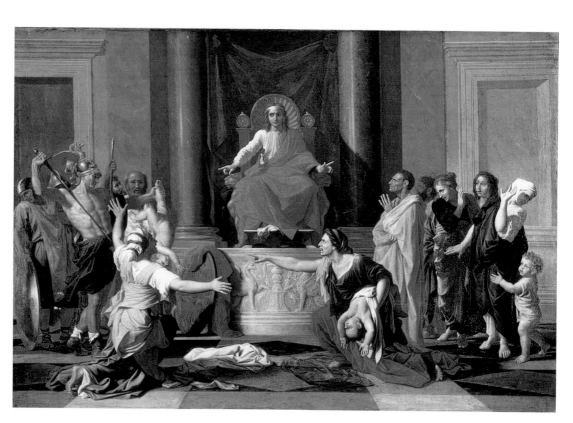

Fig. 24 · Nicolas Poussin (1594–1665)
The Judgement of Solomon, 1649
Oil on canvas · 101 × 160 cm
Musée du Louvre, Paris (7277)

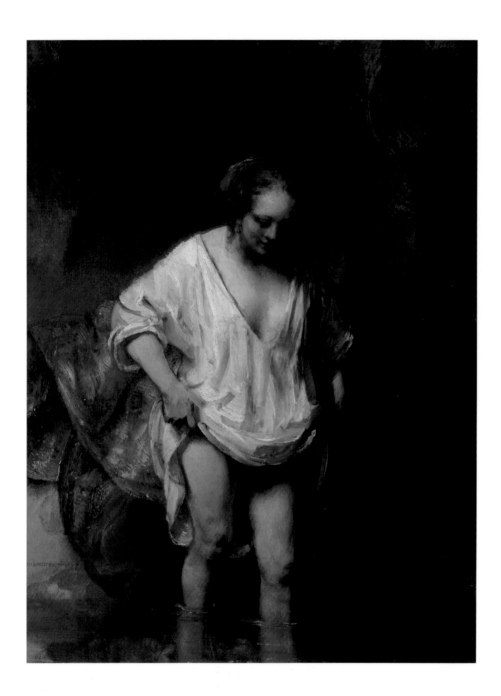

Fig. 25 · Rembrandt (1606–1669)
A Woman bathing in a Stream, 1654
Oil on oak · 61.8 × 47 cm
The National Gallery, London · Holwell Carr Bequest, 1831

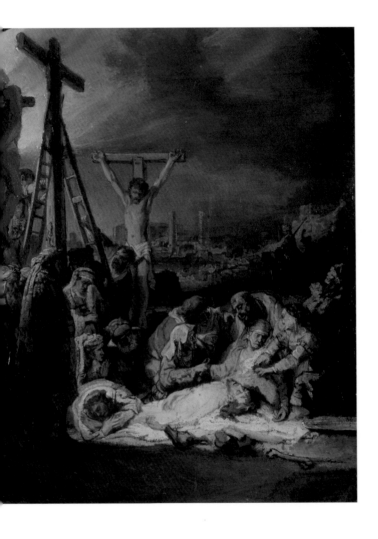

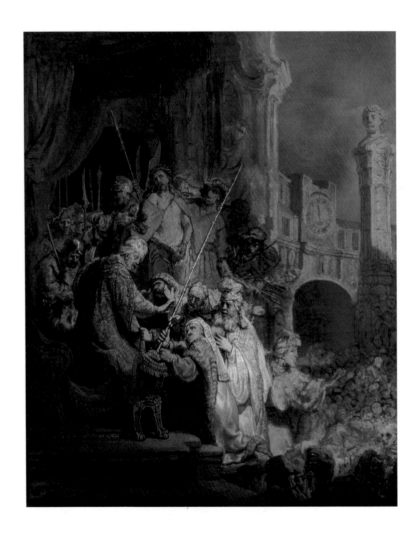

above left Fig. 26 · Rembrandt (1606–1669)
The Lamentation over the Dead Christ, about 1635
Oil on paper and pieces of canvas, mounted onto oak · 31.9 × 26.7 cm
The National Gallery, London
Presented by Sir George Beaumont, 1823/8

above right Fig. 27 · Rembrandt (1606–1669)
Ecce Homo, 1634
Oil on paper mounted onto canvas · 54.5 × 44.5 cm
The National Gallery, London

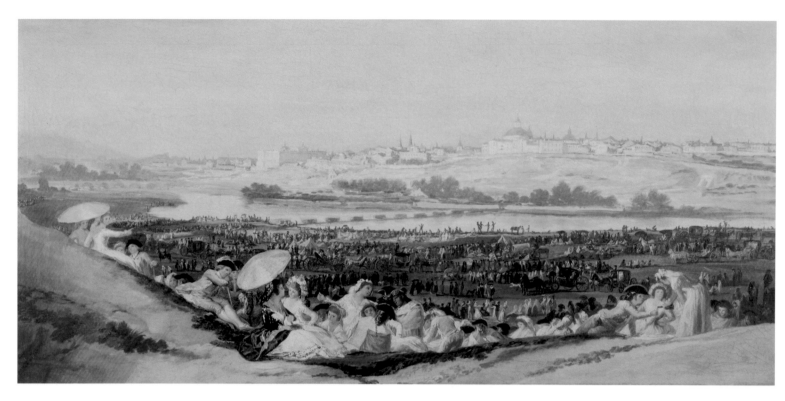

Fig. 28 · Francisco de Goya (1746–1828) *The Meadow at San Isidro*, 1794
Oil on canvas · 41.9 × 90.8 cm
Museo Nacional del Prado, Madrid

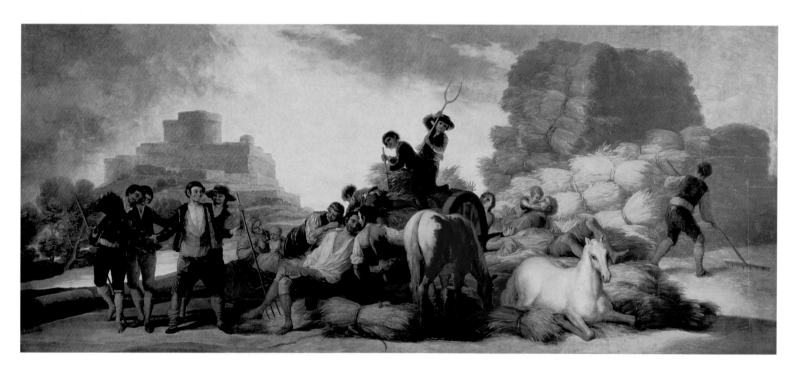

Fig. 29 · Francisco de Goya (1746–1828) *Summer, or The Harvest*, 1786
Oil on canvas · 276 × 641 cm
Museo Nacional del Prado, Madrid

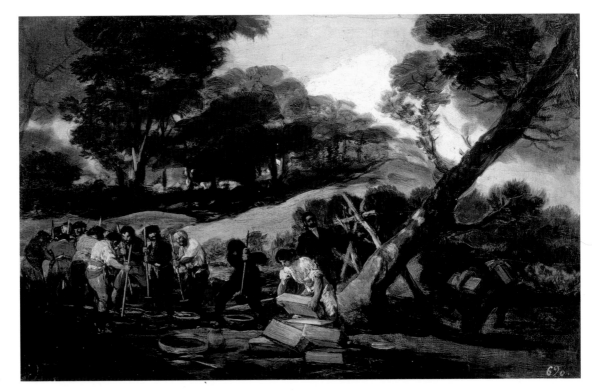

Fig. 30 · Francisco de Goya (1746–1828)
Making Powder in the Sierra de Tardienta,
about 1810–14
Oil on panel · 32.9 × 52.2 cm
Patrimonio Nacional, Royal Palace, Madrid

Fig. 31 · Francisco de Goya (1746–1828)
Making Shot in the Sierra de Tardienta,
about 1810–14
Oil on panel · 33.1 × 51.5 cm
Patrimonio Nacional, Royal Palace, Madrid

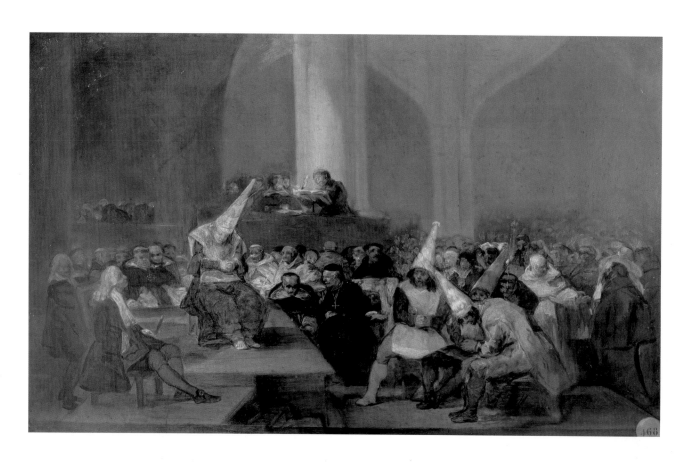

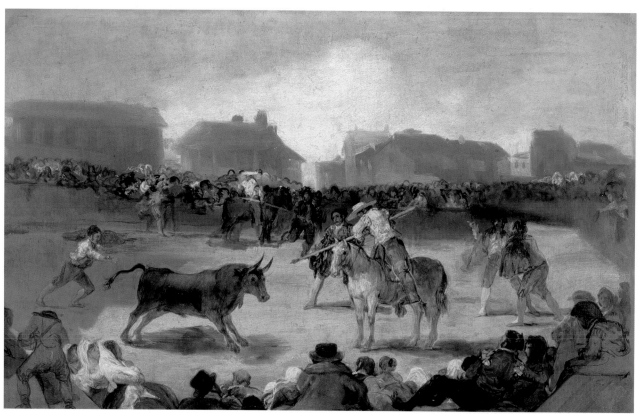

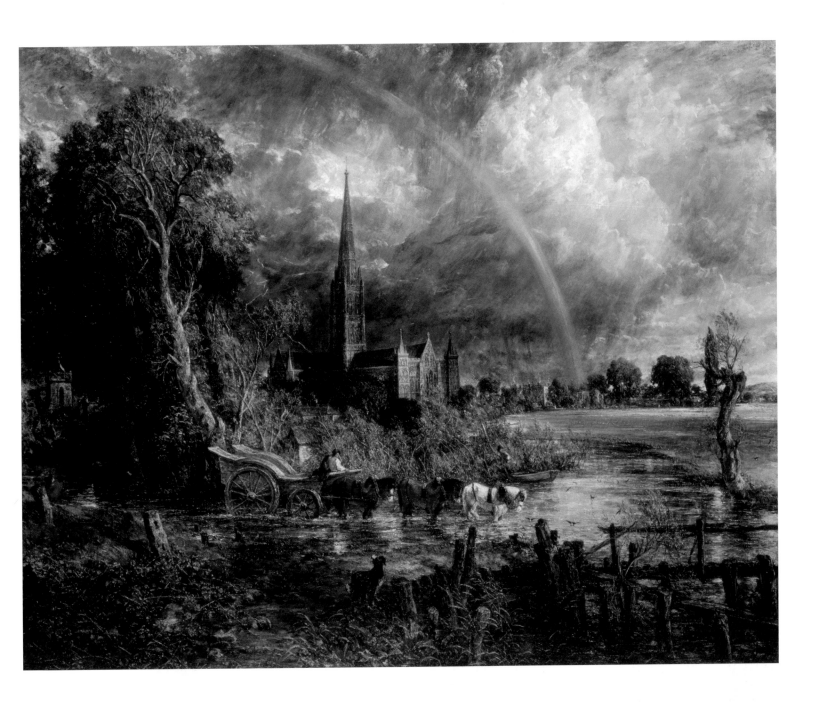

opposite above Fig. 32 · Francisco de Goya (1746–1828)
'Auto de Fe' of the Inquisition, about 1815–19
Oil on panel · 45 × 73 cm
Museo de la Real Academia de Bellas Artes de San Fernando, Madrid

opposite below Fig. 33 · Francisco de Goya (1746–1828)
Bullfight in a Village, about 1815–19
Oil on panel · 45 × 72 cm
Museo de la Real Academia de Bellas Artes de San Fernando, Madrid

Fig. 34 · John Constable (1776–1837)
Salisbury Cathedral from the Meadows, 1831
Oil on canvas · 151.8 × 189.9 cm
The National Gallery, London
On loan from a private collection since 1983

Fig. 35 · Hilaire-Germain-Edgar Degas (1834–1917)
Hélène Rouart in her Father's Study, about 1886
Oil on canvas · 162.5 × 121 cm
The National Gallery, London

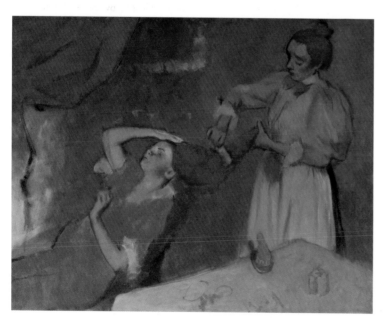

Fig. 36 · Hilaire-Germain-Edgar Degas (1834–1917)
Combing the Hair ('La Coiffure'), about 1896
Oil on canvas · 114.3 × 146.7 cm
The National Gallery, London

Notes and references

From the National Gallery *pages 46–57*

1 A selection of his work from Rubens was shown as part of the National Gallery's 2000 exhibition *Encounters*, and was fully discussed in the catalogue.

2 *Drawn to Painting*, exh. cat., Richard Kendall, Los Angeles County Museum of Art and J. Paul Getty Museum, Los Angeles 2000. See also 'Richard Wollheim meets Leon Kossoff' in *Modern Painters*, 13, no.1 (Spring 2000), expanded as 'Learning from Poussin', *artonview*, 25 (Autumn 2001), pp. 39–48.

3 See Wollheim, cited in note 2.

Leon Kossoff: Drawing from Goya *pages 70–79*

1 *Goya: Truth and Fantasy: The Small Paintings*, exh. cat., J. Wilson-Bareau and M.B. Mena Marqués, Museo del Prado, Madrid, Royal Academy of Arts, London, The Art Institute of Chicago, 1993–4. Hereafter referred to as *Small Paintings*.

2 Kossoff used the reproductions in the Classici dell'arte Rizzoli series, *L'opera pittorica completa di Velazquez*.

3 All three works have recently been on special display, Velázquez's *Christ after the Flagellation contemplated by the Christian Soul* and *The Water-Seller of Seville* in the exhibition at the National Gallery (nos 8 and 16, *Velázquez*, 18 October 2006 – 21 January 2007), Goya's *Duke of Wellington* at Apsley House itself (16 October 2006 – 14 January 2007).

4 Goya, so much in tune with Rembrandt in his unforced naturalism, promised – and the recent *Velázquez* exhibition at the National Gallery has perhaps fulfilled – the revelation of a new understanding of Velázquez, the Sevillian master who has meant so much to both artists.

5 Not necessarily the plates with the earliest numbers, they include all the signed and occasionally dated plates.

6 Charles Baudelaire, 'Quelques caricaturistes étrangers' (*Le Présent*, 15 October 1857), in *Baudelaire. Œuvres complètes*, Paris 1976, vol. II, pp. 569–70.

7 For Velázquez's paintings, see *Velázquez*, exh. cat., eds A.D. Ortiz and A.E. Pérez Sanchez, Museo Nacional del Prado, Madrid 1990, nos 21 (*Los Borrachos*); 36–40, 42 and 44 (portraits), 49 and 50 (*Aesop* and *Menippus*); 52–8 (dwarfs and buffoons). The recent *Velázquez* exhibition at the National Gallery, London (see note 3), included the equestrian portrait of *Infante Baltasar Carlos*, the dwarf *Francisco Lezcano* and *Aesop* [nos 25, 34 and 35]. Goya's apparently unique proof of *Francisco Lezcano*, recorded in the Instituto Jovellanos at Gijón, was destroyed during the Spanish Civil War of 1936–9 (see P. Gassier and J. Wilson, *Goya: His Life and Work*, London 1971, no. 112).

8 See *Goya's Last Works*, exh. cat., J. Brown and S.G. Galassi, The Frick Collection, New York 2006.

9 *Small Paintings*, pp. 156–71, nos 19–24.

10 *Small Paintings*, pp. 172–83, nos 25–9.

11 Letter to the secretary of the Academy of San Fernando, excusing himself from being present at the hanging of his recently completed portrait of the new king Fernando VII (Academy of San Fernando, Madrid). See *Small Paintings*, p. 303; Sarah Symmons, *Goya. A Life in Letters*, London 2004, p. 271, no. 275 (incomplete text).

12 A unique, bound volume of 82 prints, inscribed in pencil by Goya with his intended titles, is now in the British Museum. The title page reads: 'Fatales consequencias de la sangrienta guerra en España con Buonaparte. Y otros caprichos enfaticos, en 85 estampas.'

13 I am now inclined to think that it was this group of four paintings that Goya listed as the first and most valuable item in the inventory of his studio drawn up after the death of his wife in 1811. The 1812 inventory of works of art is headed by 'Four paintings of the same size with the number one', estimated at 1800 reales. At 450 reales each, the paintings are by far the most expensive works in the inventory, each one valued well over twice as highly as the magnificent, life-size *Majas on a balcony* and *Maja and Celestina*, estimated at 200 reales each (both in private collections). The complexity of the compositions, the large numbers of figures, even on a small scale, and the sheer *maestria* of the handling, would account for the high valuation placed on the four relatively small panels. Two much larger paintings, which bear a mark *X.1* that appears to correspond with the inventory, and a third that is closely related to them, are no longer considered to be autograph works by Goya. See J. Wilson-Bareau in *The Metropolitan Museum Journal*, 31 (1996), pp. 159–74.

14 Llorente's work was not published for another decade: *Histoire critique de l'inquisition d'Espagne*, Paris 1817–18.

15 See *Album C*, nos 85–114, in Pierre Gassier, *Les dessins de Goya. Les albums*, Fribourg 1973, nos 230–58, pp. 308–36.

16 *Goya. Drawings from the Prado*, introduction by André Malraux, London 1947; Goya drawings from *Album C*, '*Por descubrir el mobimiento de la tierra*', and 95, '*No lo saben todos*' (Malraux plates 97 and 98), both drawings are in the Museo Nacional del Prado, Madrid.

17 Not only have the Black Paintings suffered greatly from damage and subsequent restoration when they were removed from the walls of Goya's former home, but even the authenticity of a least one group of them has recently been challenged.

Drawing from Poussin *pages 92–95*

1 These and similar remarks were made when I visited Leon Kossoff in his studio, 3 and 21 August 2006. I would like to thank Leon and Peggy Kossoff for their hospitality, and Peter Goulds for introducing us. See also Kendall 2000, pp. 10–11, 23 and 42–3; Wollheim 2001, pp. 45–6 (both cited above).

2 Kossoff is insistent on 'from'. See Wollheim 2001, p. 42.

3 Kendall 2000, pp. 11–12.

4 For example, in Wollheim 2001, p. 46.

5 Quoted in Kendall 2000, pp. 22 and 19.

6 For example, in Wollheim 2001, p. 40.

Leon Kossoff

1926 Born City Road, Islington, London

1938–43 Attended Hackney Downs (Grocers) School, London

1943 Attended life drawing evening class at Toynbee Hall and Central Saint Martin's School of Art, London

1945–8 Military service in France, Belgium, Holland and Germany

1949–53 Studied at Central Saint Martin's School of Art, and at Borough Polytechnic, London, with David Bomberg (1950–2)

1954 Studied at Royal College of Art, London

1959–69 Taught at Regent Street Polytechnic, Chelsea School of Art and Central Saint Martin's School of Art

1956–present Lives and works in London

Solo Exhibitions

2007 *Leon Kossoff: Drawing from Painting*, National Gallery, London, 14 March – 1 July

2004–5 *Leon Kossoff: Selected Paintings 1956 – 2000*, Louisiana Museum of Modern Art, Humlebaek, 19 November 2004 – 28 March 2005; travelled to Museum of Art, Lucerne, 23 April – 17 July

2002 *Leon Kossoff*, Annandale Galleries, Sydney, 20 March – 22 April

 Leon Kossoff: Drawn to Painting, Poussin, Rubens and Other Subjects, Pillsbury & Peters Fine Art, Dallas, Texas, 28 June – 28 August

2001 *Drawn to Painting: Leon Kossoff Prints and Drawings after Nicolas Poussin*, National Gallery of Australia, Canberra, 17 March – 27 May

2000 *Drawn to Painting: Leon Kossoff Prints and Drawings After Nicolas Poussin*, Los Angeles County Museum of Art, 20 January – 2 April

 Poussin Landscapes by Kossoff, J. Paul Getty Museum, Los Angeles, 20 January– 2 April

 After Nicolas Poussin: New Etchings by Leon Kossoff, Metropolitan Museum of Art, New York, 28 March – 13 August

 Leon Kossoff, Mitchell-Innes & Nash, New York, 11 April – 24 May; travelled to Annely Juda Fine Art, London, 1 June – 22 July

1997 *Corner Exhibition*, Copenhagen

1996 *Leon Kossoff*, Tate, London, 6 June – 1 September

1995–6 *Leon Kossoff*, XLVI Venice Biennale, 12 June – 15 October; travelled to Dusseldorf Kunstverein, 10 December 1995 – 21 January 1996; Stedelijk Museum, Amsterdam, 8 February – 31 March

1993 *Leon Kossoff: Drawings 1985 – 1992*, Anthony d'Offay Gallery, London, 5 February– 6 March; travelled to L.A. Louver, Venice, California, 8 May – 5 June

1988 *Leon Kossoff*, Anthony d'Offay Gallery, London, 8 September – 8 October; travelled to Robert Miller Gallery, New York, 1–26 November

1984 *Leon Kossoff: Recent Work*, Fischer Fine Art Ltd., London, March – April; travelled to L.A. Louver, Venice, California, 15 November – 15 December

1983 *Leon Kossoff*, Hirschl & Adler Modern, New York, 5 – 26 March

1982 *Leon Kossoff Paintings*, L.A. Louver, Venice, California, 7 May – 5 June

1981 *Leon Kossoff: Paintings from a Decade 1970–80*, Museum of Modern Art, Oxford, May – July

 Leon Kossoff, Graves Art Gallery, Sheffield, July – August

1980–1 *Recent Drawings*, Riverside Studio, London, December – January

1979 *Leon Kossoff: Paintings and Drawings*, Fischer Fine Art Ltd, London, May – June

1975 *Leon Kossoff at Fischer Fine Art*, Fischer Fine Art Ltd, London, July – August

1973 *Leon Kossoff: Recent Paintings and Drawings*, Fischer Fine Art Ltd, London, January–February

1972 *Leon Kossoff: Recent Paintings*, Whitechapel Art Gallery, London, 19 January – 20 February

1968 *Leon Kossoff*, Marlborough Fine Art Ltd, London, April

1957–64 Five exhibitions at Beaux Arts Gallery, London: February – March 1957; September – October 1959; October – November 1961; February – March 1963; April – June 1964

Further reading

Public Collections

Astrup Fearnley Museum of Modern Art, Oslo

Art Gallery of New South Wales, Sydney

Arts Council of Great Britain, London

The Art Institute of Chicago, Chicago, Illinois

Australian National Gallery, Canberra

Berado Museum, Lisbon

British Council, London

Calouste Gubenkian Foundation, Portugal

Chrysler Museum, Provincetown, Massachusetts

Cleveland Museum of Art, Cleveland, Ohio

Contemporary Art Society, London

City Museum and Art Gallery, Leicester

Ferens Art Gallery, Kingston-Upon-Hull

J. Paul Getty Museum, Los Angeles, California

Government Art Collection, London

Cecil Higgins Museum, Bedford

The Hirshhorn Museum and Sculpture Garden, Washington DC

The Lannan Foundation, Santa Fe, New Mexico

Los Angeles County Museum of Art, Los Angeles, California

Louisiana Museum of Modern Art, Humlebaek

The Metropolitan Museum of Art, New York

The Museum of London

Museum of Modern Art, New York

National Gallery of Victoria, Melbourne

Rochdale Art Gallery, Lancashire

Rooseum Center for Contemporary Art, Malmö

Rugby Museum, Warwickshire

Santa Barbara Museum of Art, Santa Barbara, California

Scottish National Gallery of Modern Art, Edinburgh

Peter Stuyvesant Foundation, London

Swindon Museum and Art Gallery, Wiltshire

Tate, London

Thyssen-Bornemisza Collection, Lugano

Whitworth Art Gallery, University of Manchester

Leon Kossoff: Selected Paintings, 1956–2000, exh. cat., Poul Erik Tøjner, Anders Kold, interview with Per Kirkeby by Poul Erik Tøjner, Louisiana Museum of Modern Art, Humlebaek 2005

'Richard Wollheim meets Leon Kossoff', Richard Wollheim, *Modern Painters*, 13, no. 1 (Spring 2000), expanded as 'Learning from Poussin', *artonview*, 25 (Autumn 2001), published by the National Gallery of Australia, pp. 39–48

Drawn to Painting: Leon Kossoff's Drawings and Paintings After Nicholas Poussin, exh. cat., Richard Kendall, Los Angeles County Museum of Art and J. Paul Getty Museum, Los Angeles 2000

Encounters: New Art From Old, exh. cat., Richard Morphet et al., National Gallery, London 2000

Leon Kossoff, exh. cat., Paul Moorhouse, Tate, London 1996

Leon Kossoff, exh. cat., David Sylvester and Rudi Fuchs, Venice Biennale, London 1995

Leon Kossoff: Werke 1986 – 1994. Der britische Pavillon auf der Biennale Venedig 1995, supplement, Raimund Stecker, et al., Kunstverein fur die Rheinlande und Westfalen, Dusseldorf, 1995

Leon Kossoff, exh. cat. Lawrence Gowing, Anthony d'Offay Gallery, London 1988

Leon Kossoff: Paintings from a Decade 1970–80, exh. cat., David Elliott, Museum of Modern Art, Oxford 1981

Eight Figurative Painters, exh. cat., Lawrence Gowing, Yale Center for British Art, New Haven 1981

Leon Kossoff: Recent Paintings, exh. cat., David Mercer, Whitechapel Art Gallery, London 1972

Photographic credits